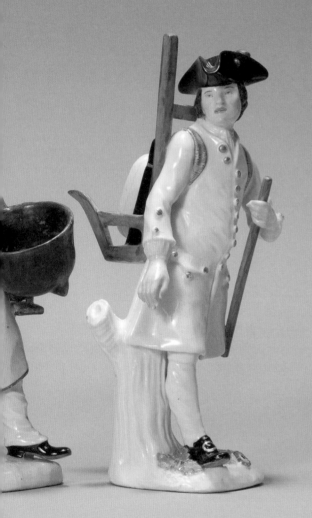
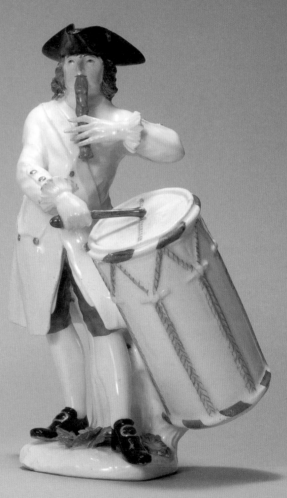

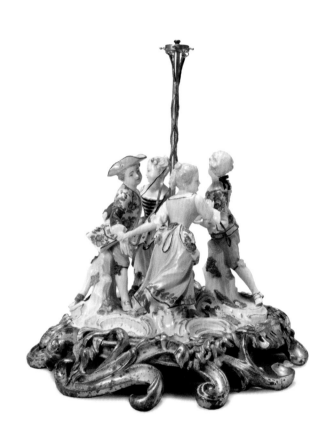

Figures of
the Enlightenment

A Catalogue of Eighteenth-Century Meissen from a Private Collection

Philip Kelleway & Tristan Sam Weller

UNICORN

Published in 2021 by

Unicorn, an imprint of Unicorn Publishing Group
5 Newburgh Street
London W1F 7RG

www.unicornpublishing.org

ISBN 978—1-913491-85-7

10 9 8 7 6 5 4 3 2 1

Printed by Finetone Ltd
Design: Jonathan Christie

For my parents -
John & Eugenie Kelleway
[P.K.]

For Lydia & Bonnie
[T.S.W.]

Contents

Acknowledgements

The idea for this book occurred several years ago and grew out of a casual conversation with the owners of the collection catalogued here. The owners wished to remain anonymous, as the intended book was to be about the Meissen pieces rather than a vainglorious eulogy regarding the collectors. At that particular point in time I was enthused about engaging with such a project, because since completing my doctorate on eighteenth-century European porcelain I had not pursued that interest much further, nor had the opportunity to do so. I had to postpone working on it, for I had just taken on the mammoth task of editing *Dutch and Flemish Flower Pieces: Paintings, Drawings and Prints up to the Nineteenth Century* (2020) by Sam Segal and Klara Alen – many thanks to Maja Passchier and Ilana Sluckin for their pivotal role in asking me to work on it, as it ranks as one of the nicest tasks I have been able to participate in as an art historian. And then along came the Covid-19 pandemic, together with lockdowns, which made the task of completing this catalogue quite a challenge. I owe a huge debt of gratitude to so many individuals.

First, I must thank the collectors – a husband and wife team of enthusiasts – of the Meissen objects presented here. Access to their collection was made all the more tricky because of the lockdowns. This leads me on to thank Tristan Sam Weller for photographing the collection between periods of lockdown restrictions. I was entrusted with the task of moving each and every item, whilst Sam carefully tiptoed around light stands, laptops and other monitors, being mindful of the need not to jog tables. The photography took many days, as it could not be rushed. It was not possible to just set up the camera and lights and simply leave them. Fine adjustments were often required, because the objects differed in size. The sculptural figures presented different lighting challenges to the flat wares (dishes) and hollow wares (cups and bowls) and, if all else failed, Sam literally resorted to energetically 'throwing light' at the objects à la Picasso to bring out the best in them and make the gilt decoration sparkle. Many thanks are also

due to all at Unicorn Publishing for taking Sam's pictures and my notes and putting them together in this most stunning catalogue.

Whilst studying for my doctorate and writing up my thesis entitled *Figures of the Enlightenment: European Porcelain Statuettes, 1745–1795*, which was completed by viva in 2005, I had the good fortune to work part-time for the antiques dealer Yvonne Adams. I was learning from an expert who was not only a respected dealer in eighteenth-century Meissen, but the author of two much-referenced books on the subject. Attending auction house viewings, auctions and manning her stand at smart antique fairs enabled me to study numerous items at close range and handle the porcelain objects, rather than just gaze at them through the glass panels of museum cabinets. This was a very useful hands-on apprenticeship, which complemented my more theoretical doctoral studies.

In relation to those years studying for and writing up a doctoral thesis, I warmly thank Professor Ludmilla Jordanova, who was my supervisor. I am also particularly grateful to Professor Richard Wilson of the School of History at the University of East Anglia and to Dr Julia Poole, the Keeper of Decorative Arts at the Fitzwilliam Museum in Cambridge, who both examined and passed my thesis many years ago on Friday 2 December 2005. Later on, Dr Danielle van den Heuvel and Dr Melissa Calaresu inspired me to look afresh at street food hawkers made in porcelain – many of these can be found here. Of course, any errors are entirely my own. Once again, I would like to thank the collectors for breathing life into this catalogue and making it possible.

P.K.
Norwich
February 2021

Figures of the Enlightenment

General Introduction to the Catalogue

The collection catalogued here is quite extensive and a feast for the eyes for anyone with an interest in eighteenth-century ceramics. A deliberate and careful balance has been struck between figures and service wares, together with a few miscellaneous items including, for example, a snuffbox [Fig. 76]. In total there are 185 items, of which 111 are figures [See Appendix I]. All the items can be dated to the eighteenth century except, that is, for one commemorative cup and saucer [Fig. 70]. This cup and saucer are dated 1810, but because the portraits decorating the cup were clearly of people born in the eighteenth century, it was allowed to be included.

The famous Blue Crossed Swords mark used to identify Meissen porcelain is on almost all the items catalogued here, either on their base in the case of service wares, or towards the bottom on the stands at the back of the figures. In just a couple of instances, there is the ghost of the mark on the bases of the figures, where it has almost completely disappeared during firing and is barely decipherable. One particularly interesting piece is a stunning chinoiserie teapot [Fig. 81], which bears the extremely rare underglaze blue mark 'M.P.M.' – Meissner Porzellan Manufaktur. There are, however, many gems and highlights in this collection.

Included are service wares painted by the finest eighteenth-century Meissen decorators, or from their workshops. There are examples of chinoiserie decoration from the hand, or workshop of Johann Gregorius Höroldt [Figs 81 and 83]; Kakiemon-style 'Indianische Blumen' (Eastern flowers) wares in the manner of Johann Ehrenfried Stadler [Figs 79 and 80]; and an écuelle stand painted by Johann Christoph Horn [Fig. 84]. There are items decorated with 'Schattenmalerei' and battle scenes [Fig. 73], a tea service with finely painted and delicate floral 'Deutsche Blumen' [Figs 63–65], and an

exquisite Mocha pot bearing Watteau-inspired scenes set against a turquoise-coloured ground [Fig. 78]. A grand table centrepiece [Fig. 62] combines the practicality of service wares with elegant figures in a fine example of graceful rococo exuberance.

Amongst the numerous figures are first-rate examples modelled by Johann Joachim Kaendler, Peter Reinicke and Johann Friedrich Eberlein [Figs 1–61]. Meissen, of course, led the way in the production of porcelain figures and many of its designs were plagiarised elsewhere. The collection presented here includes Crinoline groups, a selection of equine figures and examples from several distinct and highly collectable series, for example of street hawkers.

This collection was not formed overnight, but over more than three decades, beginning in 1982 with the purchase of a tea service decorated with bucolic groups, most probably by an unidentified outside decorator [Figs 66–69]. The vast majority of the items were purchased from Len and Yvonne Adams, who for many years ran their antiques business at No. 2 Royal Arcade, 28 Old Bond Street in London. They were amongst the main dealers of antique eighteenth-century Meissen and also ran a shop called Hart Adams Antiques in Nashville, Tennessee. Numerous art lovers were guided and assisted by the Adams in the formation of their collections. Indeed, they provided the first figures for the collection illustrated here, which were purchased in 1983 and are those flirtatious courtly couple, where the man blows a kiss to a coy lady raising her fan [Fig. 52]. *The blown kiss* is a spectacular example of the technical wizardry possible at Meissen and it is precisely this quality which continues to appeal to collectors, who understand the significant contribution made by Meissen to the applied arts.

Meissen porcelain holds a truly special place in the history of ceramics. Taking its name from a small town in southeast Germany on the River Elbe, northwest of Dresden, in Saxony, Meissen remains famous for its porcelain manufactory, which is still in production today. Until Johann Friedrich Böttger in collaboration with Ehrenfried Walther von Tschirnhaus worked out how to make porcelain in around 1710, the only porcelain known and used throughout Europe was imported from the Far East. Understandably, the potters there wanted to protect their market and were reluctant to share their knowledge.

The quest to find out how to make porcelain became an ongoing saga of intrigue, industrial espionage and jealous political and commercial machinations worthy of a film storyline. However, it was at Meissen that the technological and scientific breakthrough of how to make porcelain occurred. It may well be that Böttger was a failure as an alchemist – for his original plan was to find a way to convert common base metals into gold – but his fruitless experiments to discover the philosopher's stone (the imagined substance needed to change any metal into gold) has had a lasting legacy.

Although the manufacturing of porcelain wares was duplicated elsewhere in eighteenth-century Europe, Meissen will always be remembered for, and will maintain its special status as, the very first European porcelain in the history of ceramics. Meissen continues to fascinate people today, attracted not just by its history but also by the ceramic objects themselves. The range of objects included in this catalogue gives a good idea as to the appeal and technical virtuosity achieved by Meissen.

The fundamental essence lying at the heart of Meissen's appeal is the material itself, the recipe to make the porcelain. Indeed, the medium of porcelain was referred to in the eighteenth century as 'weisses Gold' (white gold) and as precious art objects Meissen could act as an indicator of status and wealth. Geographically, the Meissen manufactory lay close to local deposits and supplies of kaolin (china clay), one of the vital ingredients of porcelain. Meissen is made from hard-paste porcelain, which is also referred to in the secondary literature as true porcelain. Soft-paste porcelain is pejoratively named artificial porcelain, precisely because it is not kaolinic and fails, therefore, to match the paste used by oriental potters. Instead, soft-paste porcelain had bone ash or ground glass in its composition to assist in mimicking the translucency of porcelain from the Far East. The kaolin was mixed with the second essential component, namely petuntze (feldspathic china stone), which melted in the heat of the kiln to cement and hold together the clay. Most importantly, the mix of these two ingredients resulted in that translucency, which is an essential quality of porcelain, along with it being hard and non-porous.

Petuntze was also used in the mixture of the glaze, which fused with the porcelain objects following its application prior to its second firing – having already been allowed to dry and then fired to a biscuit state. The making of figures was especially time-consuming.

From an original clay or wax model of a figure, moulds would be made in fired clay or plaster of Paris. These moulds would be carefully taken from individual parts – for example, the head, arms, legs, torso – and each part had to be made from two moulds. The porcelain paste would be pressed into the moulds by hand and once the paste had shrunk, the shaped parts of the figure would be removed and assembled rather like a three-dimensional jigsaw puzzle into a complete figure. Individual parts of the figure would be stuck together using slip porcelain as an adhesive.

Drying the figures out caused them to shrink by around 5 per cent, but the first biscuit firing would shrink them a further 10 per cent, or thereabouts. The clever modellers at Meissen had to take this shrinkage into account in their designs. Underglaze colours could be applied before a second firing and enamel decoration painted on prior to a third firing. Decorating with enamels was a tricky procedure for the decorators, as the colours did not match the finished colours after passing through the kiln. Gilding (the application of gold) was applied ahead of a further firing, before being burnished (polished with a

special tool), because the gilding is dull in colour when first applied. The point behind this brief description of the making process is to appreciate how time-consuming, specialised and technical it is to make these porcelain objects. It is also important to factor in the point that many items would have been rejected due to imperfections and could have been damaged in the kiln or broken during transport. It is perhaps not such a surprise, therefore, that enthusiasts understand just how precious these eighteenth-century Meissen pieces are. The collection catalogued here contains numerous interesting and beautiful items, and I would like to draw your attention to just a few of them.

There are several portraits in the collection. There are the apotheoses of The Electress Maria Josepha of Saxony, Queen of Poland, Archduchess of Austria and of Augustus III, King of Poland, Elector of Saxony [Figs 58–59]. Medallions bear portraits of the royals shown in relief. A superbly expressive little portrait figure of the Italian dancer Casimo Maranessi [Fig. 2], after an engraving by François-Armand d'Usson, Marquis de Bonnac, is indicative of how surprisingly fast Meissen responded to trends in the world around it. Casimo Maranessi was particularly known for his comic wooden shoe dances (one imagines a balletic clog dance) and took his routine around Dublin, Paris and London throughout the 1750s whilst he was all the rage. Meissen responded to his popularity by immortalising him in a highly marketable porcelain portrait figure in his stage persona.

It is most unfortunate that the identity of the portraits in silhouette on the commemorative cup in the collection have been lost over time [Fig. 70]. Nevertheless, it remains an intriguing item and the viewer is left pondering over precisely what was so special about their card game – for the decoration on the saucer refers to a game of cards known as 'Boston' – to warrant such an unusual commission.

It would be all too easy to miss the tiny portrait on a chinoiserie saucer [Fig. 71]. Hidden amongst the decoration a cheeky smiley face secretly peeps out. This is quite possibly a truly miniature portrait of the decorator Johann Gregorius Höroldt. That it is a self-portrait is highly likely, given that artists in other areas similarly tucked away portraits of themselves. Some of the figures, however, had an ambivalent relationship with portraiture.

The Meissen figures of London street hawkers were based on engravings by Pierce Tempest after drawings by Marcellus Laroon, published for the first time in 1687 and entitled *Cryes of the City of London drawne after the Life*, which was reprinted many times [Figs 3–9]. The words 'drawne after the Life', indicates that the depicted street sellers are portraits of a kind, although their actual role as likenesses is not entirely clear. When the engravings were first issued there were people, who knew they represented 'real' people. By the time Meissen was using the engravings, the identities were probably not so clear to the modellers and decorators. Certainly, the decoration of the Quakers [Fig.

8] is perhaps a little too colourful, as they were known for their simplicity of dress. These representations from the Cries of London and the two series based on the Cries of Paris [Figs 10–21; 32–38] are perhaps better understood as representing types of people, as opposed to specific individuals.

All the Meissen porcelain hawkers are decorated in bright enamels to portray their clothing. This suggests that street life was a colourful spectacle. When such figures are arranged together, they are suggestive of bustling urban life, possibly quite different from that found outside the metropolis. In the eighteenth century, London and Paris grew into even greater cities, where new job and wealth opportunities were created and exuded a magnetic allure for many. It is useful to imagine the hawkers set against a backdrop of a teeming, almost 'exotic', cityscape as a clue to their appeal. A description given by a character in *The Expedition of Humphry Clinker* (1771) by Tobias Smollett, gives us a hint that some in the eighteenth century saw London as mysterious, romantic and glamorous:

> The cities of London and Westminster are spread out into an incredible extent. The streets, squares, rows, lanes, and alleys, are innumerable. Palaces, public buildings, and churches rise in every quarter; and, among these last, St Paul's appears with the most astonishing pre-eminence. They say it is not so large as St Peter's at Rome; but, for my own part, I can have no idea of any earthly temple more grand and magnificent.
>
> But even these superb objects are not so striking as the crowds of people that swarm in the streets. I at first imagined that some great assembly was just dismissed, and wanted to stand aside till the multitude should pass; but this human tide continues to flow, without interruption or abatement, from morn till night. Then there is such an infinity of gay equipages, coaches, chariots, chaises, and other carriages, continually rolling and shifting before your eyes, that one's head grows giddy looking at them; and the imagination is quite confounded with splendour and variety. Nor is the prospect by water less grand and astonishing ... you would think all the ships in the universe were here assembled. All that you read of wealth and grandeur in the Arabian Nights' Entertainment, and the Persian Tales, concerning Bagdad, Diarbekir, Damascus, Ispahan, and Samarkand, is here realised.
>
> Tobias Smollett, *Humphry Clinker*, London, 1985 (first pub. 1771), pp. 122-3.

The collection also has examples of figures from a Meissen series of street hawkers from the Cries of Russia [Figs 22–24]. It would be doing these figures an injustice to dismiss them as superficial portrayals of decorative exoticism. There is much fine detail here. The Meissen porcelain figures of Russian street hawkers are portrayed wearing fur-trimmed hats and coats, as well as leg-bindings to signify a harsh climate. The men's tunics belted

at the waist are visibly different from the clothing worn by figures in the Paris and London series. It does not require a great leap of the imagination from viewers to think of the Russian street hawkers in porcelain as peddling specifically Russian food items, maybe sbiten (hot beverage made from honey), pirozshki (small pastry turnovers stuffed with minced meat and onion), or kvass (a weak beer made by pouring warm water over a mixture of cereals and allowing it to ferment), to name but a few. Thematically associated prints do bear titles mentioning Russian foods.

A further interesting feature of these Russian street hawkers is that three of the males are shown sporting beards, which is unusual in porcelain representations of contemporary eighteenth-century Europeans – as opposed to mythological and biblical representations, which are not represented in this specific collection. Only the Quack doctor [Fig. 6] from the Cries of London series sports a full beard. Facial hair is, perhaps, an indicator of difference. This is a complex area of concern for eighteenth-century history.

Tsar Peter the Great had angered many Orthodox Russians, the Islamic peoples and those of other cultural traditions within his domains. He insisted Russian men should shave and adopt so-called 'German' or 'Hungarian' dress in an attempt to stamp out the most obvious manifestations of Russia's difference from Western Europe, with the shaving of beards remaining a sore point at disparate protests throughout the eighteenth and early nineteenth centuries. Fines were even imposed on the wearing of beards, although these unpopular westernising dress rules and the policy of clean shaving were difficult to enforce, as is perhaps suggested by the porcelain figures of Russians with beards and traditional garb.

As russeries, the Russian hawkers are linked to other eighteenth-century exotica, namely chinoiserie and turquerie, of which there are examples in this collection [Figs 42 and 45, respectively]. The chinoiserie service wares included in the catalogue demonstrate the high regard for, and the great impact of, Chinese culture on Europe in the eighteenth century – not least of all the fascination with porcelain. Tea, coffee and chocolate were in growing demand in eighteenth-century Europe and the patterns from China and Japan decorating service wares were a reminder of how foreign, luxurious and exotic these beverages were. The decoration on porcelain and the themes of the figures reveal a general inquisitiveness about European encounters with the rest of the world and commonly held perceptions on differences in humanity during the period of the Enlightenment.

Even amongst the representations of street hawkers, there are subtle details. Some are better dressed than others. A few wear clogs, others shoes. Three of the figures from the small-scale farmer series [Figs 25–27] are barefoot, as are several others [Figs 39–41; 44]. This might suggest varying levels of prosperity and divergent customer bases, thus helping to emphasise that the populations at large were not homogenous and that

social subdivisions existed amongst the 'ordinary' people. The Meissen figures certainly do possess considerable anthropological and sociological detail, and are compelling visual records of entire sectors of society which otherwise might never have found representation in the decorative arts. In this regard, the Meissen porcelain is not merely concerned with superficial decoration, but is instead intended to engage the eyes and minds of the viewers. Having said this, it is possibly the joyous colour of the objects, when assembled together, which continues to capture the initial interest of viewers.

Being small, the figures could be displayed in many different ways, on mantelshelves, in cupboards, on furniture or on ornate wall brackets. They could also be moved easily from room to room. The figures themselves often relate to food and entertainment. They gesture, sometimes with their mouths open as if calling aloud, and proffer their goods for closer inspection or as if about to play their musical instruments to the viewer. Figures of food hawkers, especially, seem to remind us of the ties between these objects and dining. In the eighteenth century porcelain figures could have been shown in the round by being placed on a dining table. In that setting they would have appeared animated by virtue of the candlelight, which would have cast flickering shadows and caused the colours and glazes on them to sparkle, as well as the gilt decoration on the service wares. If the figures had been placed on mirrors, the playful effects of candlelight could have been enhanced by magnifying the light and reinforcing the illusory sense of movement in the manner of a deceptive *trompe l'œil*. Even without candlelight, however, the Meissen porcelain displayed in this catalogue assists us today in capturing a glimpse of the colour and spectacle of life in the eighteenth century.

Catalogue

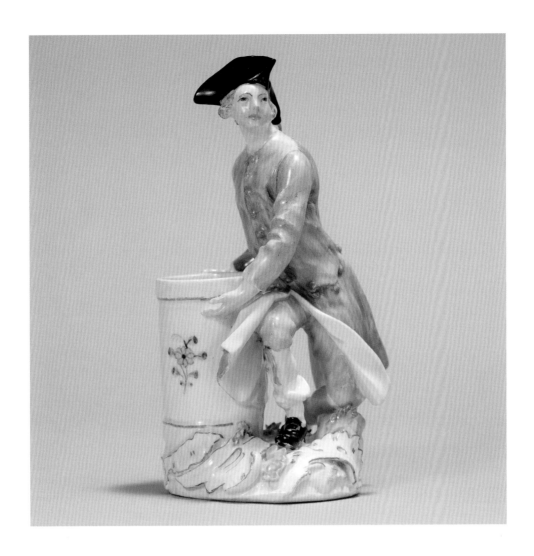

Fig. 1

Kneeling man holding a cylindrical container
Meissen, c. 1755.
Hard-paste porcelain painted in enamel colours.
Model by Johann Joachim Kaendler.
Height 15.5cm.

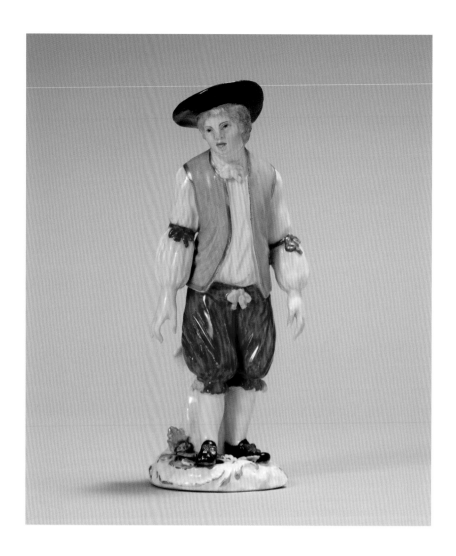

Fig. 2

Portrait figure of the Italian comic dancer Casimo Maranessi
After an engraving by François-Armand d'Usson, Marquis de Bonnac.
Meissen, c. 1755–60.
Hard-paste porcelain painted in enamel colours and gilt.
Model by Johann Joachim Kaendler.
Height 15.3cm.

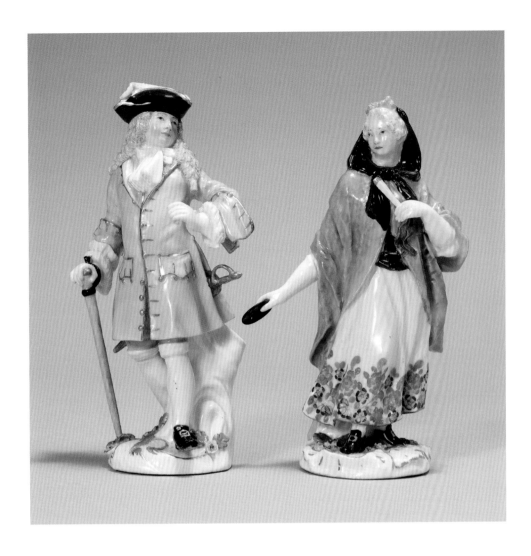

Fig. 3

(Left) The trickster from the Cries of London
Based on the engraving *The Squire of Alsatia* by Pierce Tempest after Marcellus Laroon.
Meissen, c. 1750.
Hard-paste porcelain painted in enamel colours and gilt.
Model by Johann Joachim Kaendler and Peter Reinicke.
Height 14.3cm.

(Right) Courtesan from the Cries of London
Based on the engraving *London Curtezan* by Pierce Tempest after Marcellus Laroon.
Meissen, c. 1750.
Hard-paste porcelain painted in enamel colours and gilt.
Model by Johann Joachim Kaendler and Peter Reinicke.
Height 13.5cm.

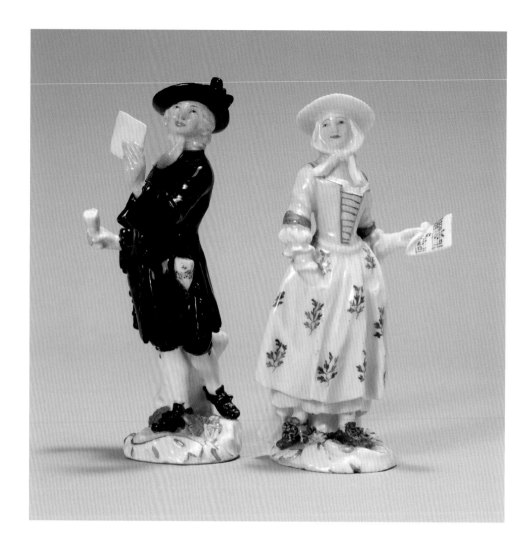

Fig. 4

(Left) Ballad singer and hawker from the Cries of London
Based on the engraving *A Merry new Song* by Pierce Tempest after Marcellus Laroon.
Meissen, c. 1750.
Hard-paste porcelain painted in enamel colours and gilt.
Model by Johann Joachim Kaendler and Peter Reinicke.
Height 12.7cm.

(Right) Woman ballad singer and hawker from the Cries of London
Based on the engraving *A Merry new Song* by Pierce Tempest after Marcellus Laroon.
Meissen, c. 1755.
Hard-paste porcelain painted in enamel colours and gilt.
Model by Johann Joachim Kaendler and Peter Reinicke.
Height 12.3cm.

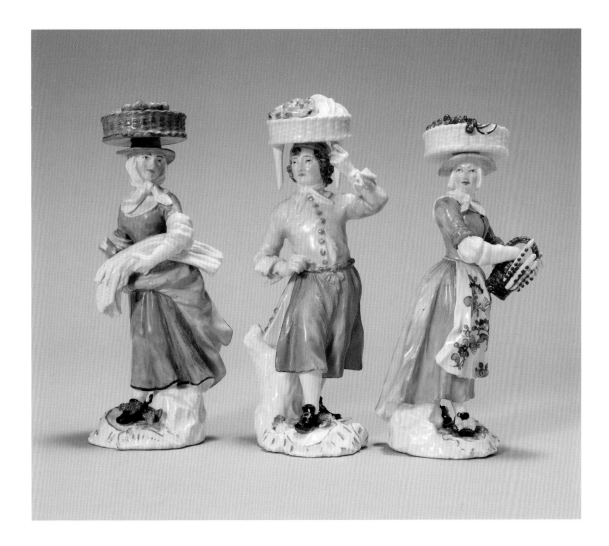

Fig. 5

(Left) Cucumber hawker with sheaf of dill from the Cries of London
Based on the engraving *Delicate Cowcumbers to pickle* by Pierce Tempest after Marcellus Laroon.
Meissen, c. 1750. Hard-paste porcelain painted in enamel colours and gilt.
Model by Johann Joachim Kaendler and Peter Reinicke. Height 15.5cm.

(Centre) Baking pears hawker from the Cries of London
Based on the engraving *Any Bakeing Peares* by Pierce Tempest after Marcellus Laroon.
Meissen, c. 1750. Hard-paste porcelain painted in enamel colours and gilt.
Model by Johann Joachim Kaendler. Height 16cm.

(Right) Cherry hawker from the Cries of London
Based on the engraving *Six pence a pound fair Cherryes* by Pierce Tempest after Marcellus Laroon.
Meissen, c. 1750. Hard-paste porcelain painted in enamel colours and gilt.
Model by Johann Joachim Kaendler and Peter Reinicke. Height 15.1cm.

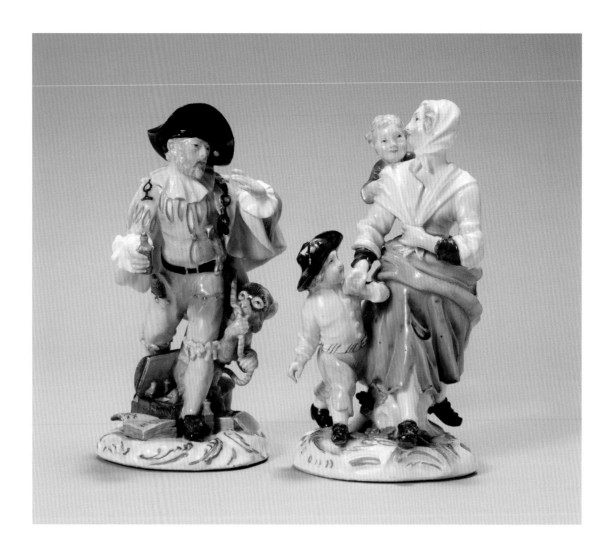

Fig. 6

(Left) Quack doctor from the Cries of London
Based on the engraving *Mountabanck* by Pierce Tempest after Marcellus Laroon.
Meissen, c. 1744–50.
Hard-paste porcelain painted in enamel colours and gilt.
Model by Johann Joachim Kaendler and Peter Reinicke.
Height 14.8cm.

(Right) Beggar woman with children from the Cries of London
Based on the engraving *The London Begger* by Pierce Tempest after Marcellus Laroon.
Meissen, c. 1755.
Hard-paste porcelain painted in enamel colours and gilt.
Model by Johann Joachim Kaendler and Peter Reinicke.
Height 15.4cm.

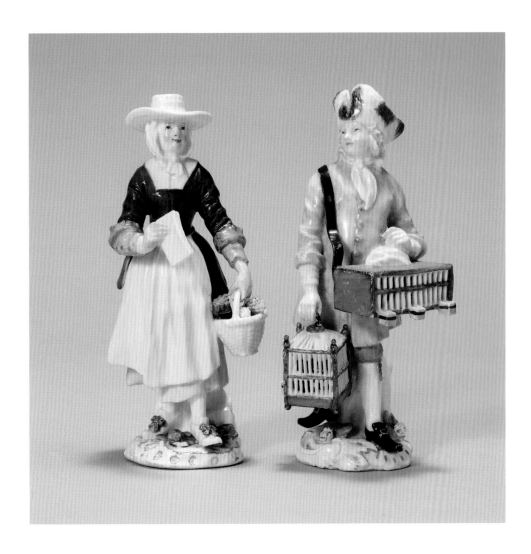

Fig. 7

(Left) Wax and wafers hawker from the Cries of London
Based on the engraving *Buy any Wax or Wafers* by Pierce Tempest after Marcellus Laroon.
Meissen, c. 1755.
Hard-paste porcelain painted in enamel colours and gilt.
Model by Johann Joachim Kaendler and Peter Reinicke.
Height 12.1cm.

(Right) Bird hawker from the Cries of London
Based on the engraving *Buy a fine singing Bird* by Pierce Tempest after Marcellus Laroon.
Meissen, c. 1745–50.
Hard-paste porcelain painted in enamel colours and gilt.
Model by Johann Joachim Kaendler.
Height 12.2cm.

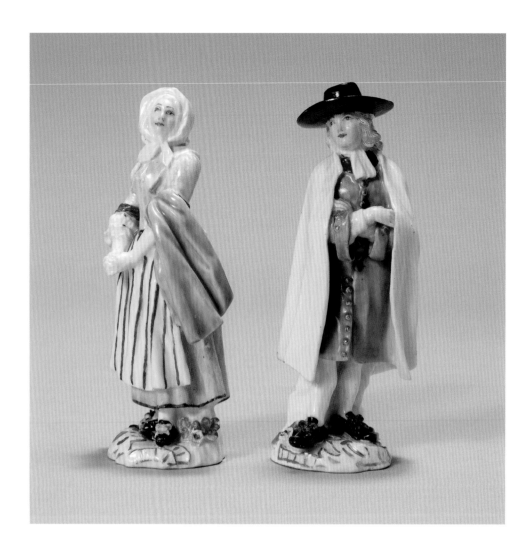

Fig. 8

(Left) Quakeress from the Cries of London
Based on the engraving *The London Quaker* by Pierce Tempest after Marcellus Laroon.
Meissen, c. 1750.
Hard-paste porcelain painted in enamel colours and gilt.
Model by Johann Joachim Kaendler.
Height 10.4cm.

(Right) Quaker from the Cries of London
Based on the engraving *John the Quaker* by Pierce Tempest after Marcellus Laroon.
Meissen, c. 1750.
Hard-paste porcelain painted in enamel colours and gilt.
Model by Johann Joachim Kaendler.
Height 10.6cm.

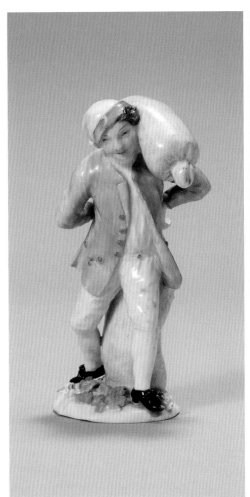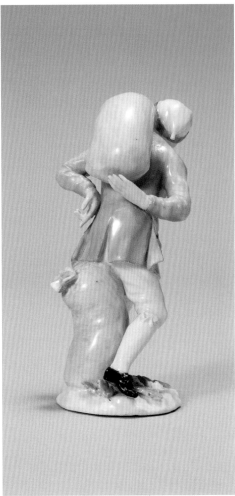

Fig. 9

Coalman from the Cries of London
Based on the engraving *Small Coale* by Pierce Tempest after Marcellus Laroon.
Meissen, c. 1745.
Hard-paste porcelain painted in enamel colours.
Model by Johann Joachim Kaendler.
Height 10.5cm.

Fig. 9a

Another view of Fig. 9
Note the inventive use of the sack as a support.

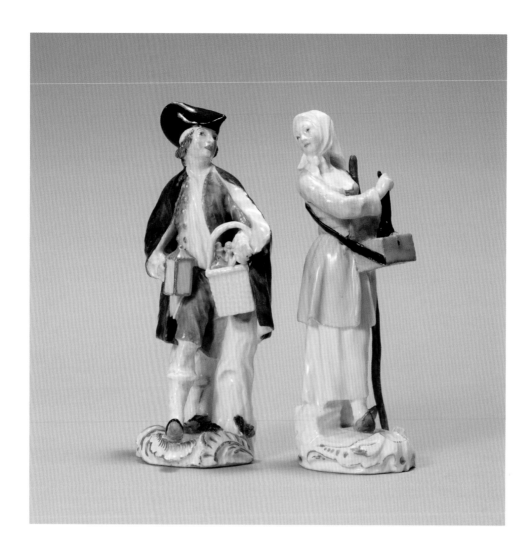

Fig. 10

(Left) Night watchman from the Cries of Paris
Based on the original design by Christophe Huet.
Meissen, c. 1755.
Hard-paste porcelain painted in enamel colours and gilt.
Model by Peter Reinicke.
Height 14.4cm.

(Right) Marmot hawker from the Cries of Paris
Based on the original design by Christophe Huet.
Meissen, c. 1755.
Hard-paste porcelain painted in enamel colours and gilt.
Model by Peter Reinicke.
Height 14.2cm.

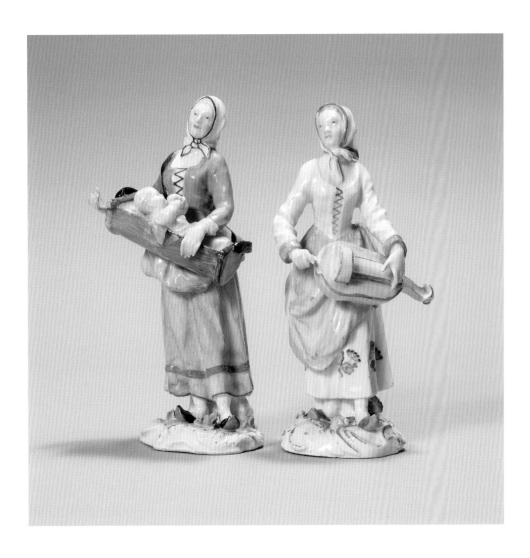

Fig. 11

(Left) Beggar woman with child from the Cries of Paris
Based on the original design by Christophe Huet.
Meissen, c. 1755.
Hard-paste porcelain painted in enamel colours and gilt.
Model by Peter Reinicke.
Height 14.2cm.

(Right) Hurdy-gurdy player from the Cries of Paris
Based on the original design by Christophe Huet.
Meissen, c. 1755.
Hard-paste porcelain painted in enamel colours and gilt.
Model by Peter Reinicke.
Height 13.8cm.

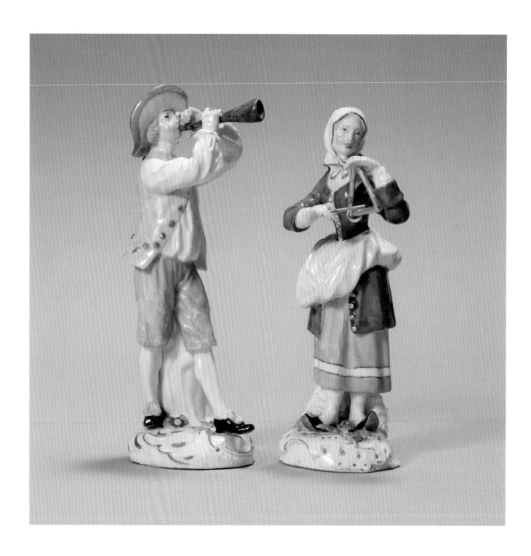

Fig. 12

(Left) Street musician with horn from the Cries of Paris
Based on the original design by Christophe Huet.
Meissen, c. 1755.
Hard-paste porcelain painted in enamel colours and gilt.
Model by Peter Reinicke.
Height 14.8cm.

(Right) Street musician with triangle from the Cries of Paris
Based on the original design by Christophe Huet.
Meissen, c. 1755.
Hard-paste porcelain painted in enamel colours and gilt.
Model by Peter Reinicke.
Height 14.1cm.

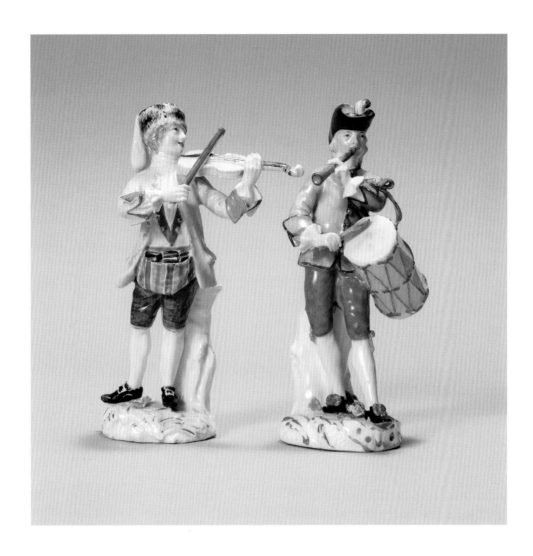

Fig. 13

(Left) Fiddler with song books from the Cries of Paris
Based on the original design by Christophe Huet.
Meissen, c. 1755.
Hard-paste porcelain painted in enamel colours and gilt.
Model by Peter Reinicke.
Height 14.1cm.

(Right) Street musician with drum and whistle from the Cries of Paris
Based on the original design by Christophe Huet.
Meissen, c. 1755.
Hard-paste porcelain painted in enamel colours and gilt.
Model by Peter Reinicke.
Height 14.6cm.

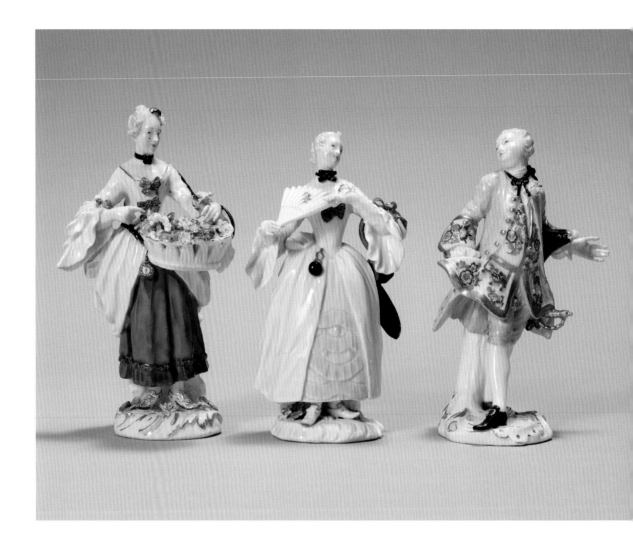

Fig. 14

(Left) Hawker with flowers from the Cries of Paris
Based on the original design by Christophe Huet.
Meissen, c. 1755. Hard-paste porcelain painted in enamel colours and gilt.
Model by Peter Reinicke. Height 13.9cm.

(Centre) Courtesan from the Cries of Paris
Based on the original design by Christophe Huet.
Meissen, c. 1755. Hard-paste porcelain painted in enamel colours.
Model by Peter Reinicke. Height 12.9cm.

(Right) Rake from the Cries of Paris
Based on the original design by Christophe Huet.
Meissen, c. 1755. Hard-paste porcelain painted in enamel colours and gilt.
Model by Peter Reinicke. Height 13cm.

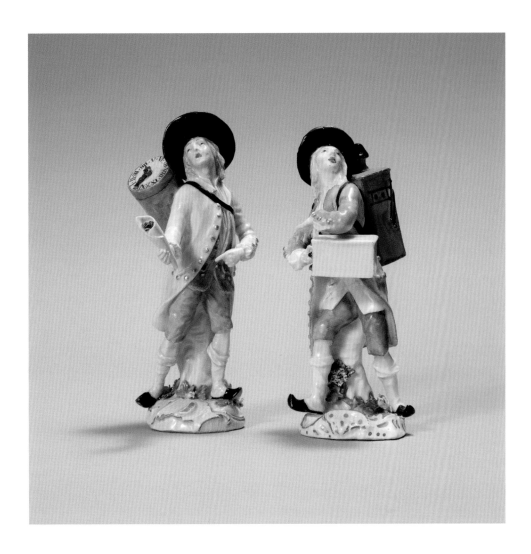

Fig. 15

(Left) Hawker of lottery tickets from the Cries of Paris
Based on the original design by Christophe Huet.
Meissen, c. 1755.
Hard-paste porcelain painted in enamel colours and gilt.
Model by Peter Reinicke.
Height 15.3cm.

(Right) Peep-show man with magic lantern from the Cries of Paris
Based on the original design by Christophe Huet.
Meissen, c. 1755.
Hard-paste porcelain painted in enamel colours and gilt.
Model by Peter Reinicke.
Height 14.7cm.

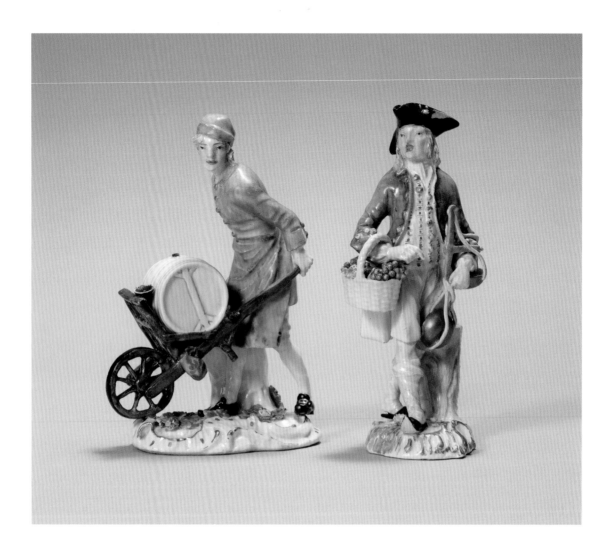

Fig. 16

(Left) Hawker with barrel of vinegar from the Cries of Paris
Based on the original design by Christophe Huet.
Meissen, c. 1755.
Hard-paste porcelain painted in enamel colours and gilt.
Model by Peter Reinicke.
Height 13.6cm.

(Right) Hawker with grapes from the Cries of Paris
Based on the original design by Christophe Huet.
Meissen, c. 1755.
Hard-paste porcelain painted in enamel colours and gilt.
Model by Peter Reinicke.
Height 14.2cm.

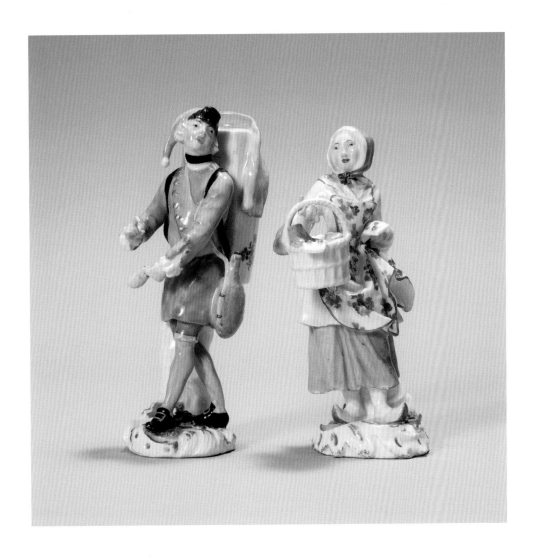

Fig. 17

(Left) Hawker with liquorice water or tisane from the Cries of Paris
Based on the original design by Christophe Huet.
Meissen, c. 1755.
Hard-paste porcelain painted in enamel colours and gilt.
Model by Peter Reinicke.
Height 13.9cm.

(Right) Hawker with pastries from the Cries of Paris
Based on the original design by Christophe Huet.
Meissen, c. 1755.
Hard-paste porcelain painted in enamel colours and gilt.
Model by Peter Reinicke.
Height 13.6cm.

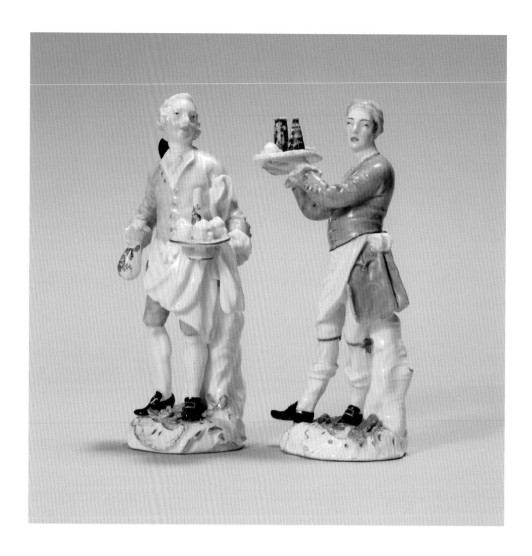

Fig. 18

(Left) Hawker with lemonade from the Cries of Paris
Based on the original design by Christophe Huet.
Meissen, c. 1755.
Hard-paste porcelain painted in enamel colours and gilt.
Model by Peter Reinicke.
Height 14.3cm.

(Right) Hawker with pastries and lemonade from the Cries of Paris
Based on the original design by Christophe Huet.
Meissen, c. 1755.
Hard-paste porcelain painted in enamel colours and gilt.
Model by Peter Reinicke.
Height 13.8cm.

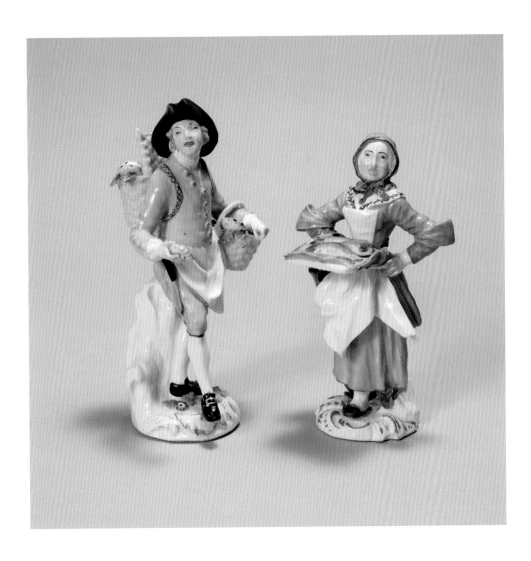

Fig. 19

(Left) Hawker with oysters from the Cries of Paris
Based on the original design by Christophe Huet.
Meissen, c. 1755.
Hard-paste porcelain painted in enamel colours and gilt.
Model by Peter Reinicke.
Height 15cm.

(Right) Hawker with fish from the Cries of Paris
Based on the original design by Christophe Huet.
Meissen, c. 1755.
Hard-paste porcelain painted in enamel colours and gilt.
Model by Peter Reinicke.
Height 13.3cm.

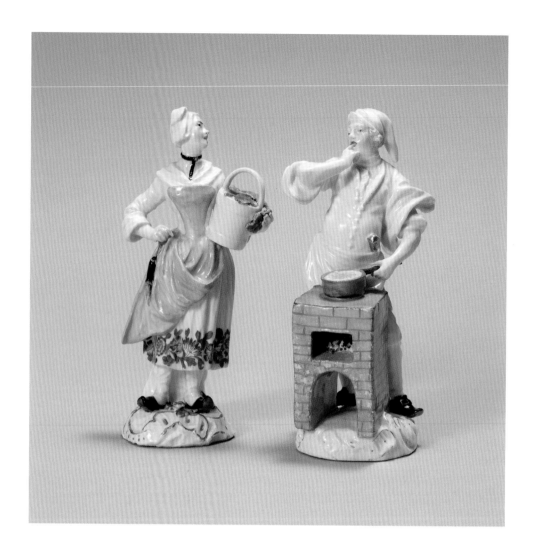

Fig. 20

(Left) Hawker with vegetables or herbs from the Cries of Paris
Based on the original design by Christophe Huet.
Meissen, c. 1755.
Hard-paste porcelain painted in enamel colours and gilt.
Model by Peter Reinicke.
Height 13.9cm.

(Right) Street food hawker beside a stove from the Cries of Paris
Based on the original design by Christophe Huet.
Meissen, c. 1755.
Hard-paste porcelain painted in enamel colours and gilt.
Model by Peter Reinicke.
Height 14cm.

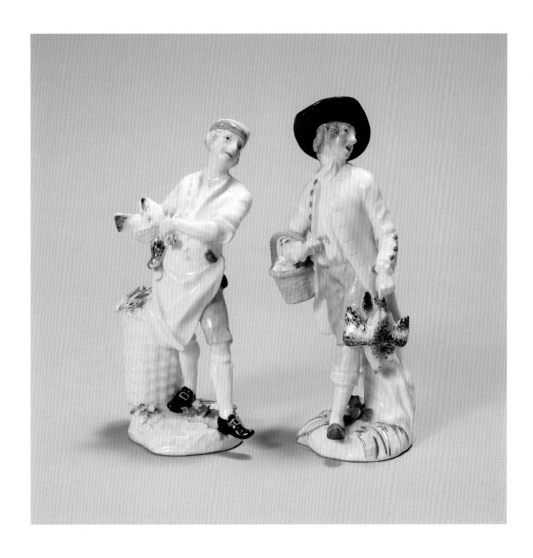

Fig. 21

(Left) Hawker plucking a bird from the Cries of Paris
Based on the original design by Christophe Huet.
Meissen, c. 1755.
Hard-paste porcelain painted in enamel colours and gilt.
Model by Peter Reinicke.
Height 13.5cm.

(Right) Hawker with poultry and basket of eggs from the Cries of Paris
Based on the original design by Christophe Huet.
Meissen, c. 1755.
Hard-paste porcelain painted in enamel colours and gilt.
Model by Peter Reinicke.
Height 14.3cm.

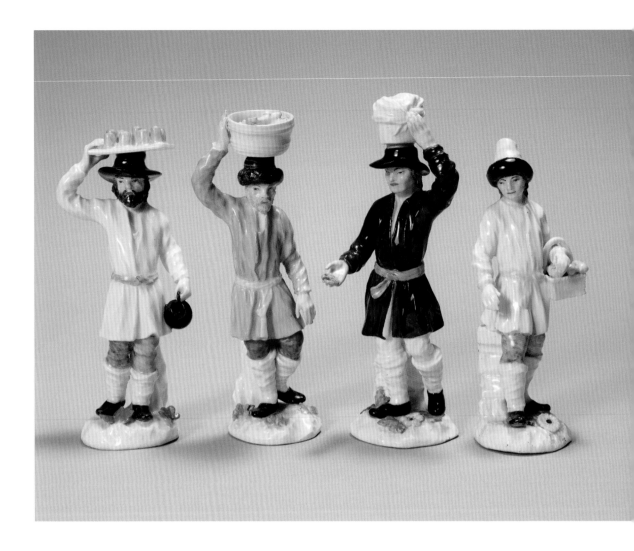

Fig. 22

(Left) Hawker with tray of goods and a jug from the Cries of Russia
Meissen, c. 1750. Hard-paste porcelain painted in enamel colours.
Model possibly by Peter Reinicke. Height 15.9cm.

(Second from Left) Hawker carrying a tub of fish on his head from the Cries of Russia
Meissen, c. 1750. Hard-paste porcelain painted in enamel colours.
Model possibly by Peter Reinicke. Height 16.5cm.

(Third from Left) Hawker of pretzels from the Cries of Russia
Meissen, c. 1750. Hard-paste porcelain painted in enamel colours.
Model possibly by Peter Reinicke. Height 17.3cm.

(Right) Hawker with basket of goods from the Cries of Russia
Meissen, c. 1750. Hard-paste porcelain painted in enamel colours.
Model possibly by Peter Reinicke. Height 15.1cm.

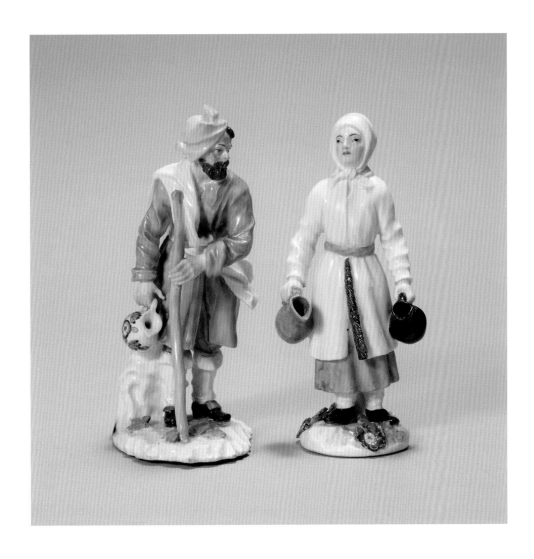

Fig. 23

(Left) Hawker with jug of water or lemonade from the Cries of Russia
Meissen, c. 1750.
Hard-paste porcelain painted in enamel colours.
Model possibly by Peter Reinicke.
Height 13.5cm.

(Right) Water carrier or milkmaid from the Cries of Russia
Meissen, c. 1750.
Hard-paste porcelain painted in enamel colours.
Model possibly by Peter Reinicke.
Height 13cm.

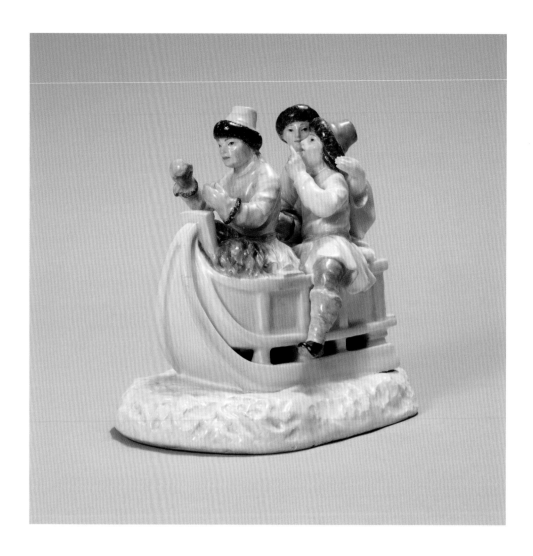

Fig. 24

Troika, or sleigh [horse(s) missing], with driver and two passengers from the Cries of Russia
Meissen, c. 1755.
Hard-paste porcelain painted in enamel colours.
Model possibly by Johann Joachim Kaendler.
Height 14.3cm.

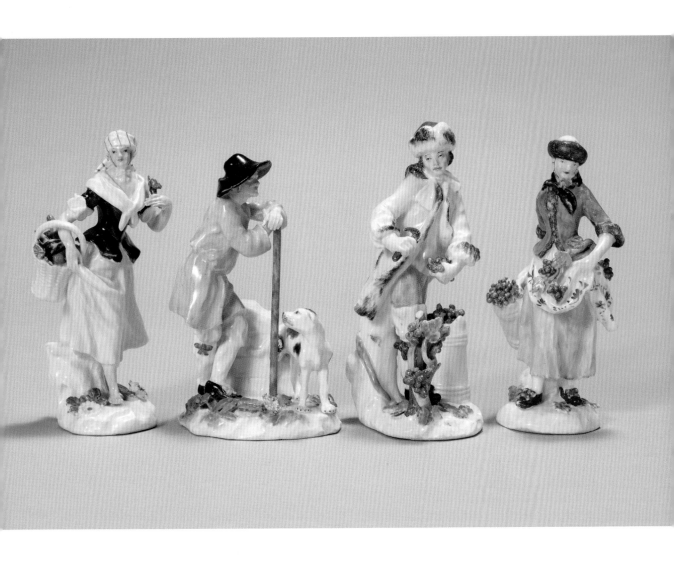

Fig. 25

(Left) Woman vegetable hawker from the small-scale Farmer Series
Meissen, c. 1745. Hard-paste porcelain painted in enamel colours.
Model possibly by Peter Reinicke. Height 11.6cm.

(Second from Left) Peasant leaning on a staff from the small-scale Farmer Series
Meissen, c. 1745. Hard-paste porcelain painted in enamel colours.
Model possibly by Peter Reinicke. Height 10.5cm.

(Third from Left) Vintager gathering grapes from the small-scale Farmer Series
Meissen, c. 1745. Hard-paste porcelain painted in enamel colours.
Model possibly by Peter Reinicke. Height 11.8cm.

(Right) Woman vintager gathering grapes from the small-scale Farmer Series
Meissen, c. 1745–52. Hard-paste porcelain painted in enamel colours.
Model possibly by Peter Reinicke. Height 11.1cm.

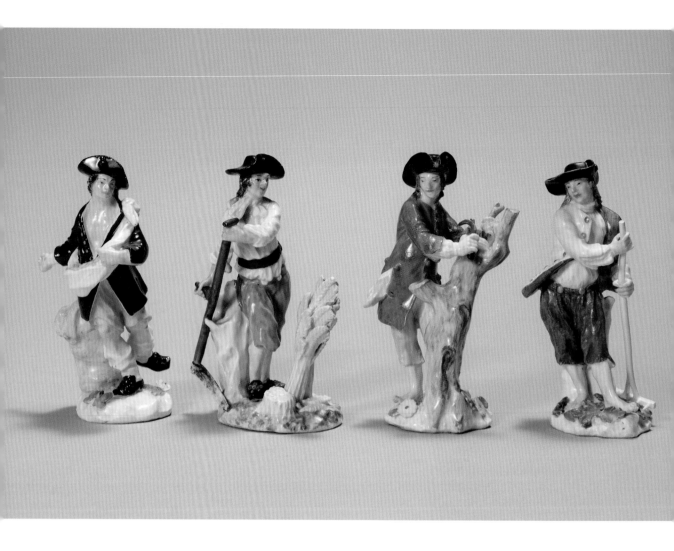

Fig. 26

(Left) Sower from the small-scale Farmer Series
Meissen, c. 1750–55. Hard-paste porcelain painted in enamel colours and gilt.
Model possibly by Peter Reinicke. Height 11.6cm.

(Second from Left) Peasant reaping wheat with a scythe from the small-scale Farmer Series
Meissen, c. 1750. Hard-paste porcelain painted in enamel colours.
Model possibly by Peter Reinicke. Height 11.7cm.

(Third from Left) Peasant grafting or pruning from the small-scale Farmer Series
Meissen, c. 1750–55. Hard-paste porcelain painted in enamel colours.
Model possibly by Peter Reinicke. Height 11.8cm.

(Right) Peasant with rake from the small-scale Farmer Series
Meissen, c. 1750. Hard-paste porcelain painted in enamel colours and gilt.
Model possibly by Peter Reinicke. Height 11.5cm.

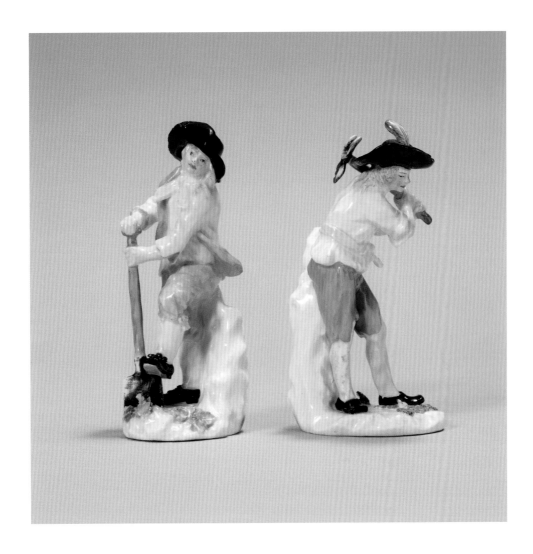

Fig. 27

(Left) Peasant digging with a spade from the small-scale Farmer Series
Meissen, c. 1750.
Hard-paste porcelain painted in enamel colours.
Model possibly by Peter Reinicke.
Height 11.6cm.

(Right) Peasant tilling or hoeing from the small-scale Farmer Series
Meissen, c. 1748.
Hard-paste porcelain painted in enamel colours.
Model possibly by Peter Reinicke.
Height 11.6cm.

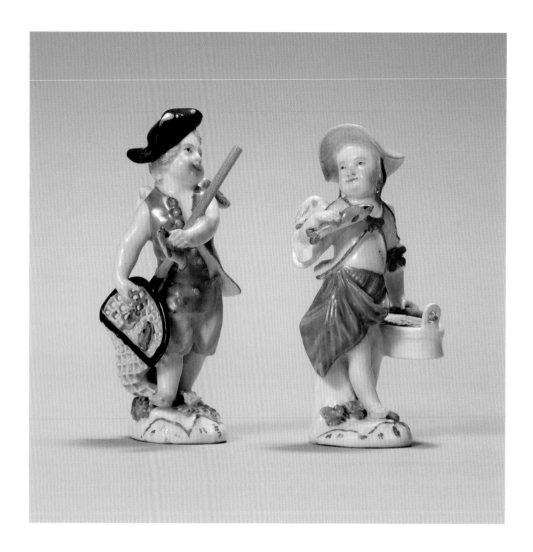

Fig. 28

A pair of winged putti in the guise of fisherfolk
Meissen, c. 1745.
Hard-paste porcelain painted in enamel colours and gilt.
Model by Johann Joachim Kaendler.
Height 9.5cm (boy); 9cm (girl).

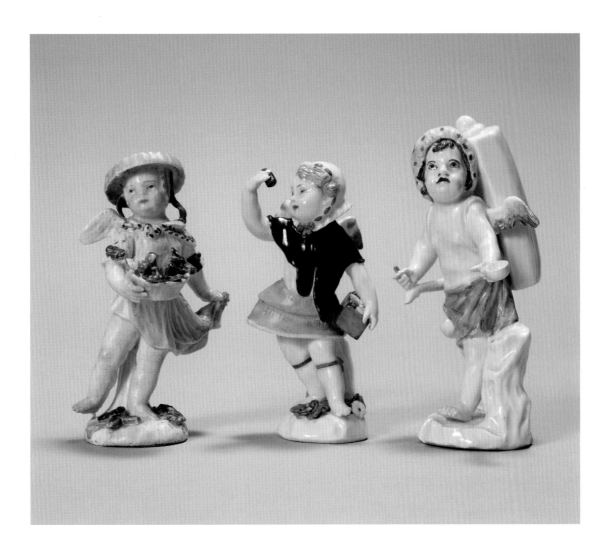

Fig. 29

(Left) Winged putto as a flower hawker
Meissen, c. 1750. Hard-paste porcelain painted in enamel colours.
Model by Johann Joachim Kaendler. Height 8.5cm.

(Centre) Winged putto in the guise of a perfume hawker
Meissen, c. 1750. Hard-paste porcelain painted in enamel colours.
Model by Johann Joachim Kaendler. Height 8.3cm.

(Right) Winged putto in the guise of a liquorice water or tisane hawker
Meissen, c. 1750. Hard-paste porcelain painted in enamel colours.
Model by Johann Joachim Kaendler. Height 9.8cm.

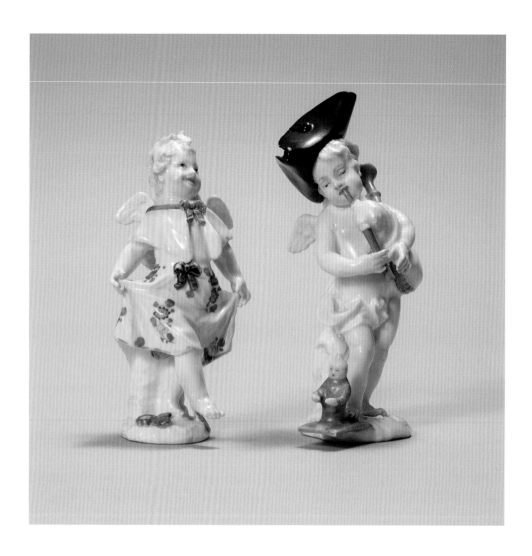

Fig. 30

(Left) Winged girl putto dancing
Meissen, c. 1750.
Hard-paste porcelain painted in enamel colours.
Model by Johann Joachim Kaendler.
Height 9.7cm.

(Right) Winged putto in the guise of a puppeteer with bagpipes
Meissen, c. 1750.
Hard-paste porcelain painted in enamel colours.
Model by Johann Joachim Kaendler.
Height 11cm.

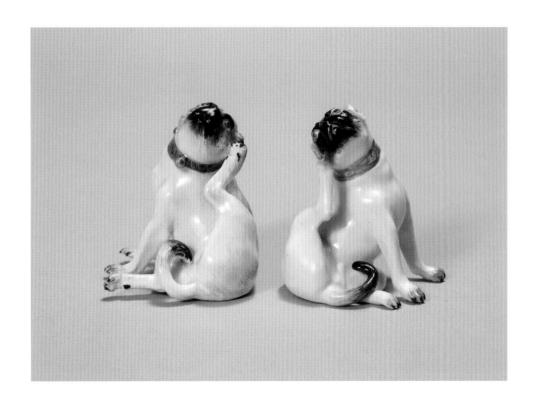

Fig. 31

A pair of free-standing (as in no base) pug dogs scratching their ears
Meissen, c. 1740–45.
Hard-paste porcelain painted in enamel colours and gilt.
Model by Johann Joachim Kaendler.
Height (both) 5.8cm.

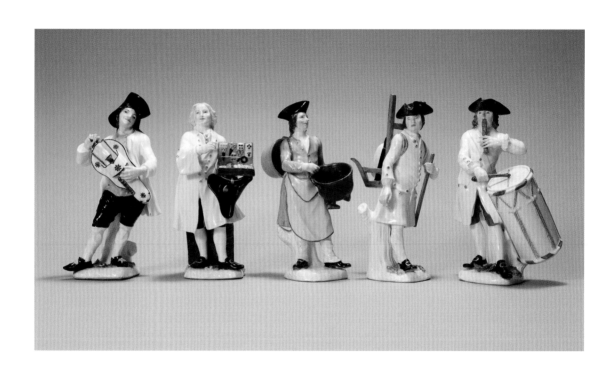

Fig. 32

Five figures from the first and tall series of the Cries of Paris
Based on engravings after drawings by Edmé Bouchardon.
See also the following seven illustrations, Figs 33–38.

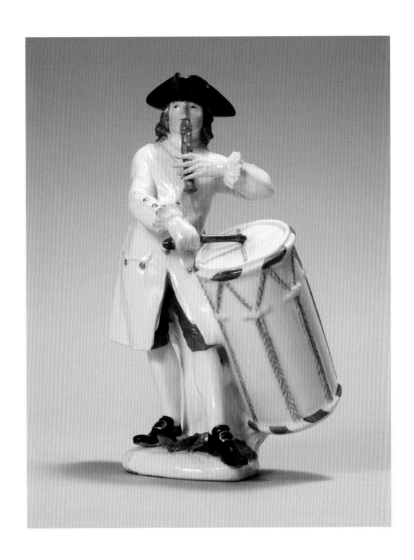

Fig. 33

Fife and drum player from the first and tall series of the Cries of Paris
Meissen, c. 1740–45.
Hard-paste porcelain painted in enamel colours and gilt.
Model by Johann Joachim Kaendler and Peter Reinicke.
Height 19.5cm.

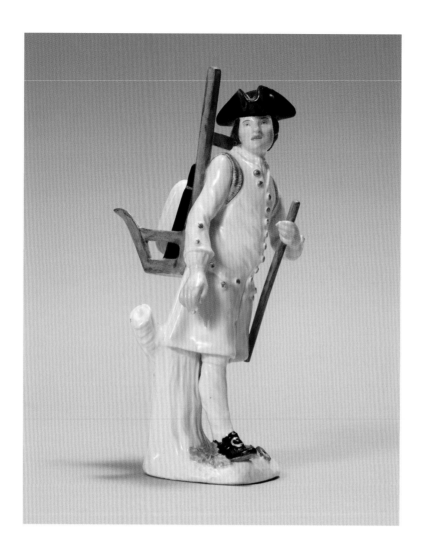

Fig. 34

Porter from the first and tall series of the Cries of Paris
Meissen, c. 1740–45.
Hard-paste porcelain painted in enamel colours and gilt.
Model by Johann Joachim Kaendler and Peter Reinicke.
Height 19.8cm.

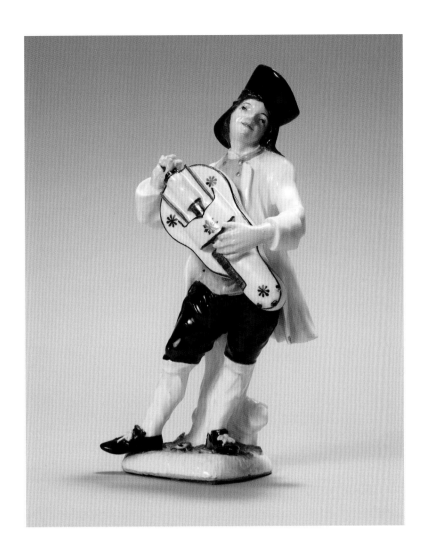

Fig. 35

Provençal hurdy-gurdy player from the first and tall series of the Cries of Paris
Meissen, c. 1740–45.
Hard-paste porcelain painted in enamel colours and gilt.
Model by Johann Joachim Kaendler and Peter Reinicke.
Height 20.2cm.

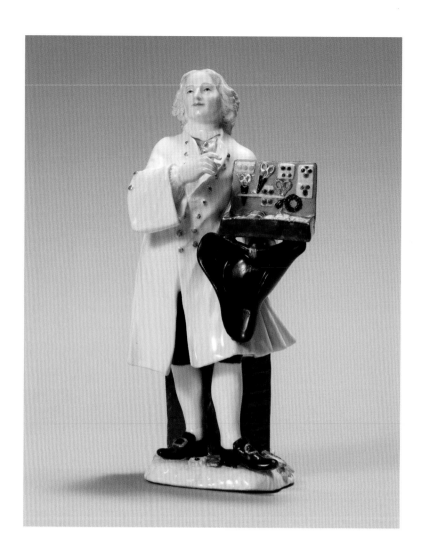

Fig. 36

Trinket hawker from the first and tall series of the Cries of Paris
Meissen, c. 1740–45.
Hard-paste porcelain painted in enamel colours and gilt.
Model by Johann Joachim Kaendler and Peter Reinicke.
Height 19.1cm.

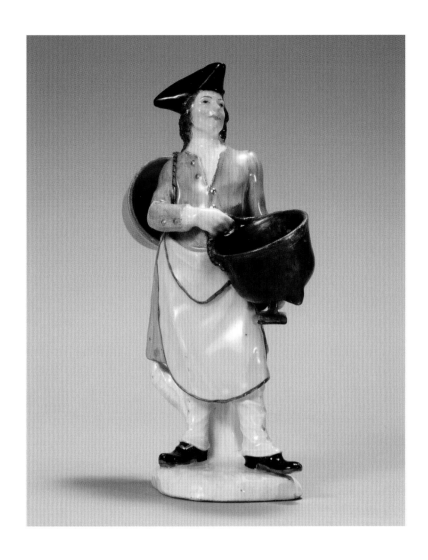

Fig. 37

Ironmonger from Auvergne from the first and tall series of the Cries of Paris
Meissen, c. 1740–45.
Hard-paste porcelain painted in enamel colours and gilt.
Model by Johann Joachim Kaendler and Peter Reinicke.
Height 19.3cm.

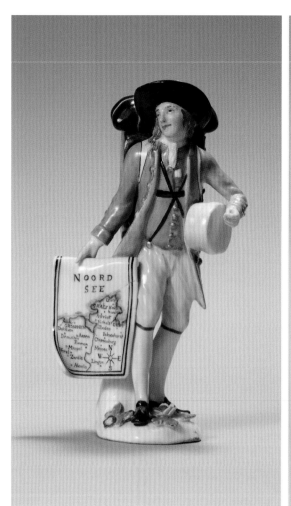
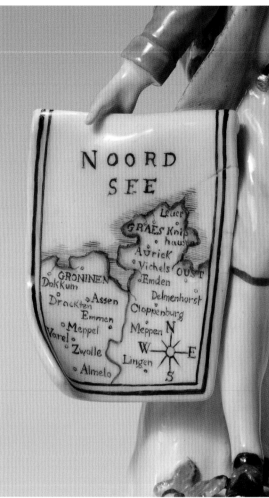

Fig. 38

Map hawker from the first and tall series of the Cries of Paris
Meissen, c. 1744.
Hard-paste porcelain painted in enamel colours and gilt.
Model by Peter Reinicke.
Height 16.5cm.

Fig. 38a

Detail of Fig. 38

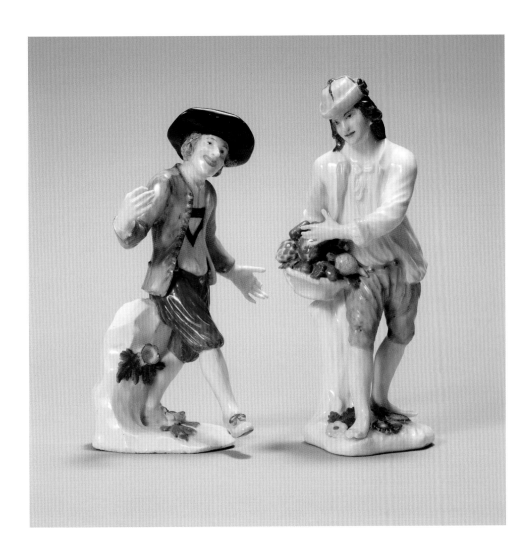

Fig. 39

(Left) Tyrolean dancing peasant
Meissen, c. 1740.
Hard-paste porcelain painted in enamel colours and gilt.
Model by Johann Joachim Kaendler.
Height 16.8cm.

(Right) Vegetable hawker
Meissen, c. 1745.
Hard-paste porcelain painted in enamel colours and gilt.
Model by Johann Friedrich Eberlein.
Height 18.4cm.

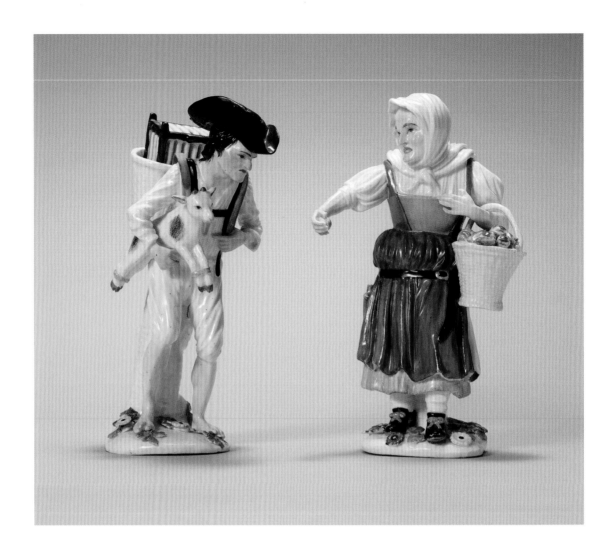

Fig. 40

(Left) Peasant with kid and a pannier
Meissen, c. 1737.
Hard-paste porcelain painted in enamel colours.
Model by Johann Joachim Kaendler.
Height 17.4cm.

(Right) Peasant fruit hawker
Meissen, c. 1738.
Hard-paste porcelain painted in enamel colours and gilt.
Model by Johann Joachim Kaendler.
Height 18cm.

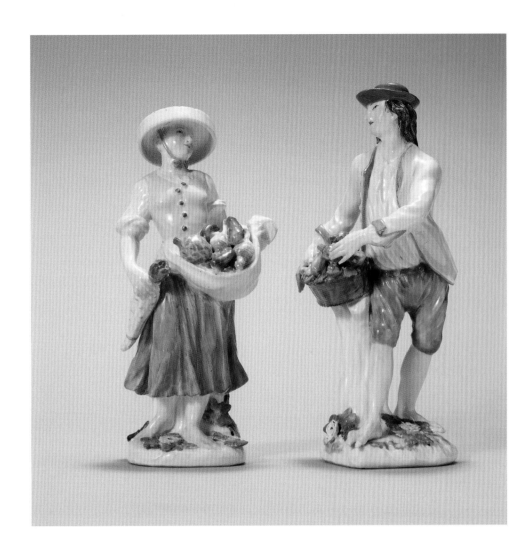

Fig. 41

A pair of vegetable hawkers
Meissen, c. 1745.
Hard-paste porcelain painted in enamel colours and gilt.
Models by Johann Friedrich Eberlein.
Height 17.7cm (woman); 18.8cm (man).

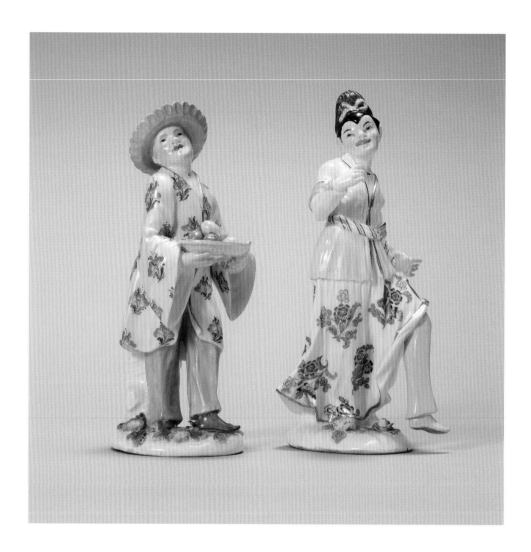

Fig. 42

A pair of Chinese figures
Meissen, c. 1743.
Hard-paste porcelain painted in enamel colours and gilt.
Models by Peter Reinicke.
Height 15.9cm (man); 16.8cm (woman).

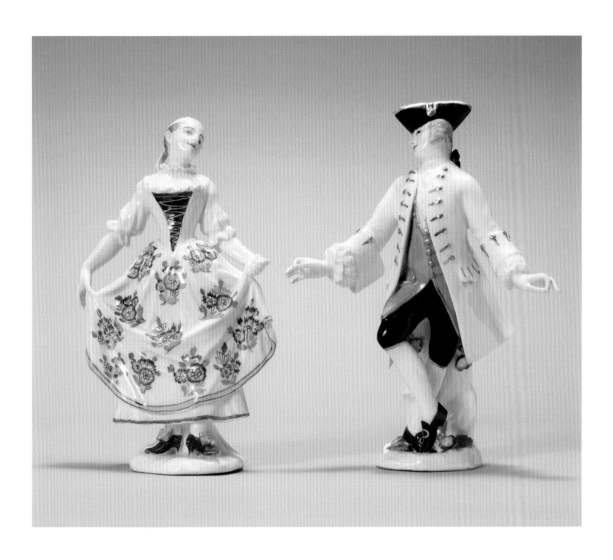

Fig. 43

Dancing harlequinade Columbine and a dancing master
Meissen, c. 1745.
Hard-paste porcelain painted in enamel colours (and gilt on the master).
Models by Johann Joachim Kaendler.
Height 17.5cm (Columbine); 17.8cm (dance master).

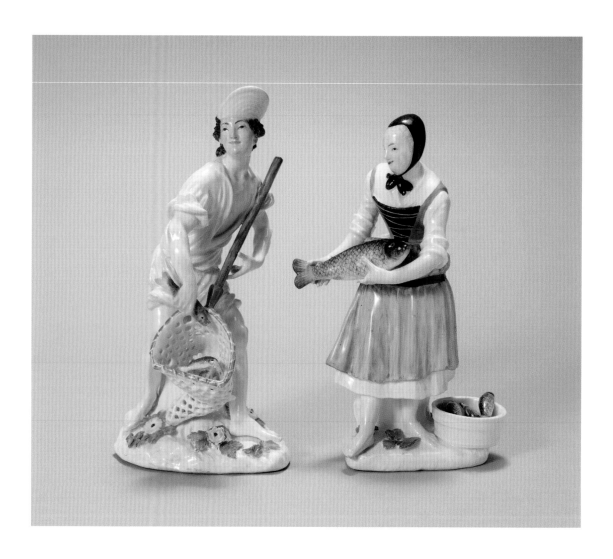

Fig. 44

A pair of fisherfolk
Meissen, c. 1748.
Hard-paste porcelain painted in enamel colours.
Models by Johann Joachim Kaendler.
Height 19.8cm (man); 18.6cm (woman).

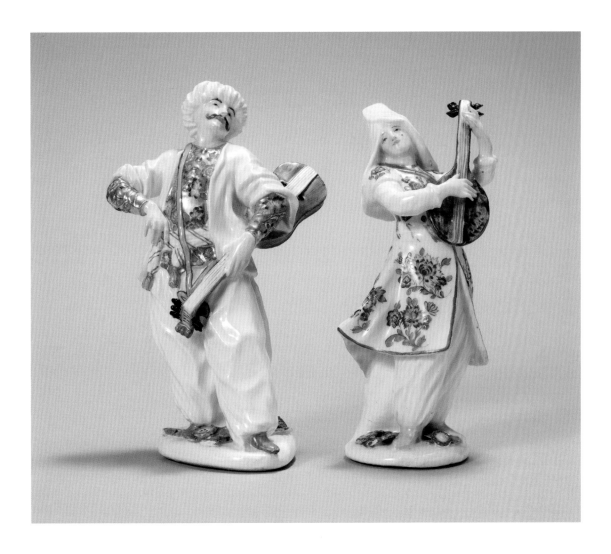

Fig. 45

A pair of Turkish musicians
He is based on an engraving, which includes the character referred to as 'the Amorous Turk', after a painting by Nicolas Lancret.
Meissen, c. 1744.
Hard-paste porcelain painted in enamel colours and gilt.
Models by Peter Reinicke and Johann Friedrich Eberlein.
Height 17.6cm (man); 16.8cm (woman).

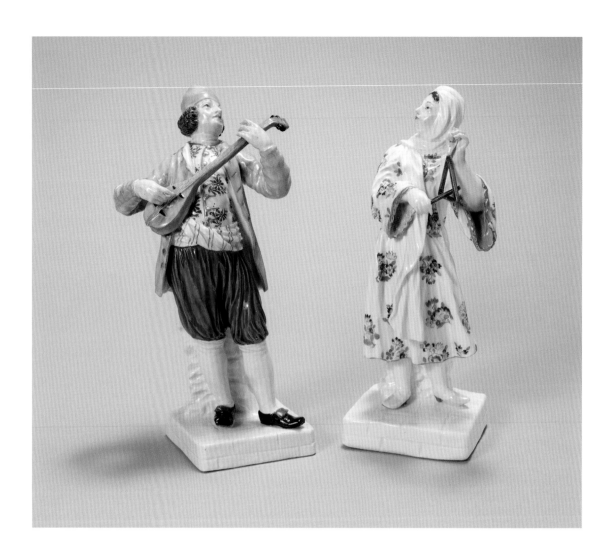

Fig. 46

A pair of Greek musicians
Meissen, c. 1748.
Hard-paste porcelain painted in enamel colours and gilt.
Models by Johann Friedrich Eberlein.
Height (both) 20.3cm.

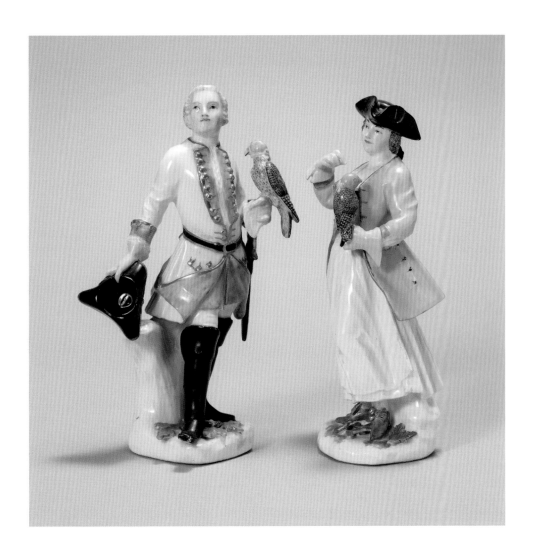

Fig. 47

A pair of falconers
Meissen, c. 1744.
Hard-paste porcelain painted in enamel colours and gilt.
Models by Johann Friedrich Eberlein.
Height 17.8cm (man); 17.3cm (woman).

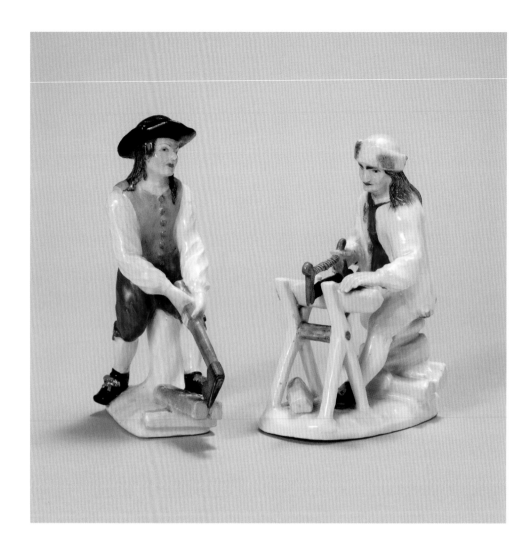

Fig. 48

(Left) Woodcutter with an axe
Meissen, c. 1745.
Hard-paste porcelain painted in enamel colours.
Model by Johann Joachim Kaendler.
Height 13.5cm.

(Right) Carpenter with a saw
Meissen, c. 1745.
Hard-paste porcelain painted in enamel colours.
Model by Johann Joachim Kaendler.
Height 12.8cm.

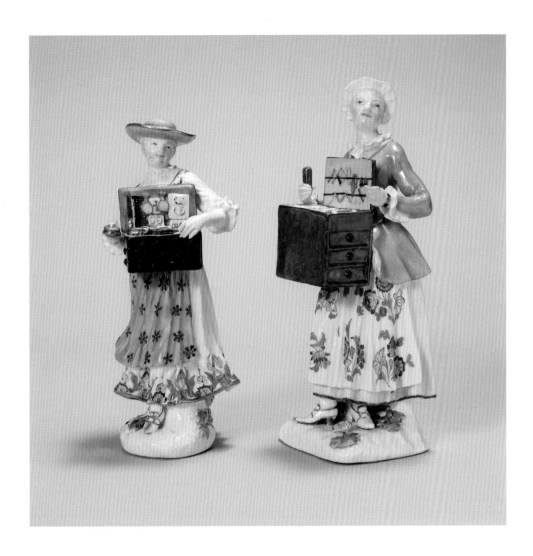

Fig. 49

(Left) Tyrolean trinket hawker
Meissen, c. 1748.
Hard-paste porcelain painted in enamel colours and gilt.
Model by Johann Joachim Kaendler.
Height 16.3cm.

(Right) Trinket hawker
Meissen, c. 1750–60.
Hard-paste porcelain painted in enamel colours.
Model by Johann Joachim Kaendler.
Height 18.4cm.

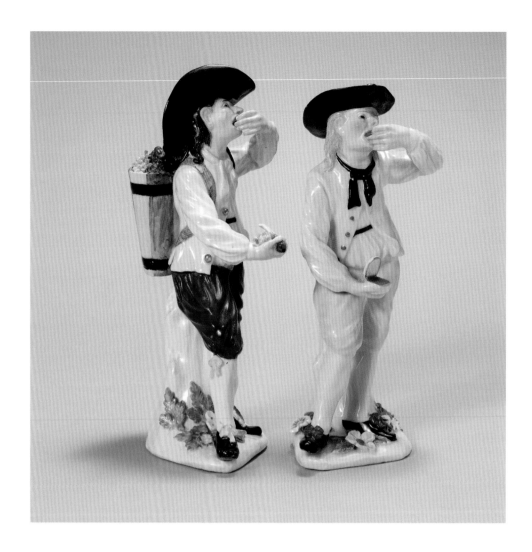

Fig. 50

(Left) Peasant vintager eating grapes
Meissen, c. 1740.
Hard-paste porcelain painted in enamel colours and gilt.
Model by Johann Joachim Kaendler.
Height 19.3cm.

(Right) Peasant taking snuff
Meissen, c. 1740.
Hard-paste porcelain painted in enamel colours and gilt.
Model by Johann Joachim Kaendler.
Height 18.3cm.

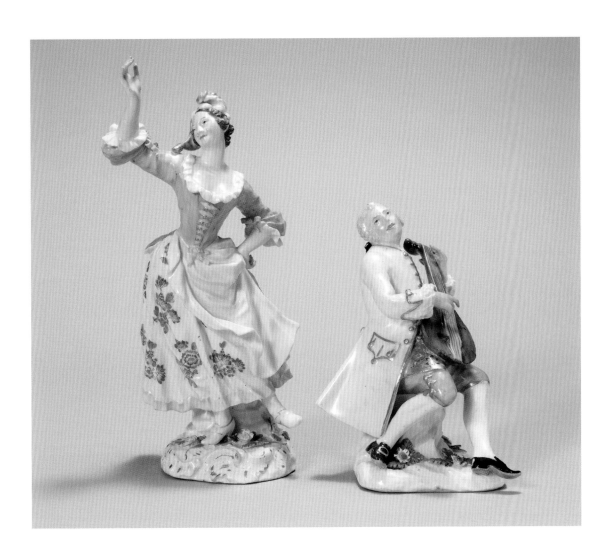

Fig. 51

(Left) Dancer
Meissen, c. 1755.
Hard-paste porcelain painted in enamel colours and gilt.
Model by Johann Joachim Kaendler.
Height 19.8cm.

(Right) Lute player
Meissen, c. 1745.
Hard-paste porcelain painted in enamel colours and gilt.
Model by Johann Joachim Kaendler.
Height 13.1cm.

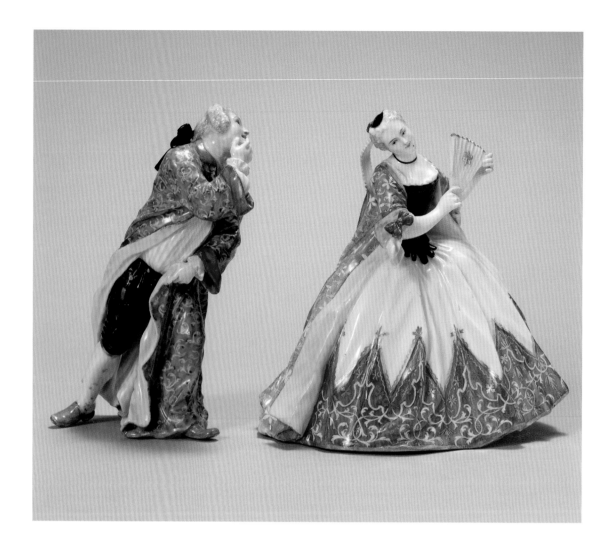

Fig. 52

Crinoline group: the blown kiss
Inspired by an engraving after a painting by Jean-Baptiste Pater.
Meissen, c. 1736. Hard-paste porcelain painted in enamel colours and gilt.
Models by Johann Joachim Kaendler. Height 14.4cm (man); 14.1cm (woman).

Fig. 52a (Opposite top)
Detail of underside looking up the skirt of the woman in Fig. 52

Fig. 52b (Opposite centre)
Detail of the couple in Fig. 52

Fig. 52c (Opposite bottom)
Rearranging the figures can appear to change the storyline.
This is an appealing added feature of these diminutive statuettes.

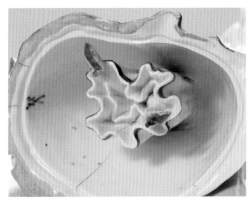

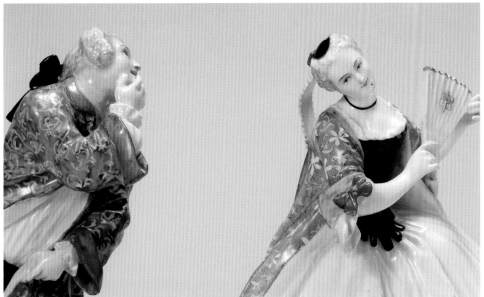

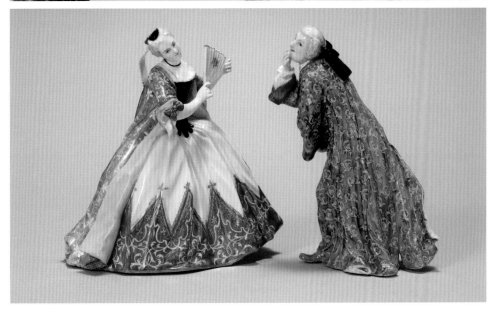

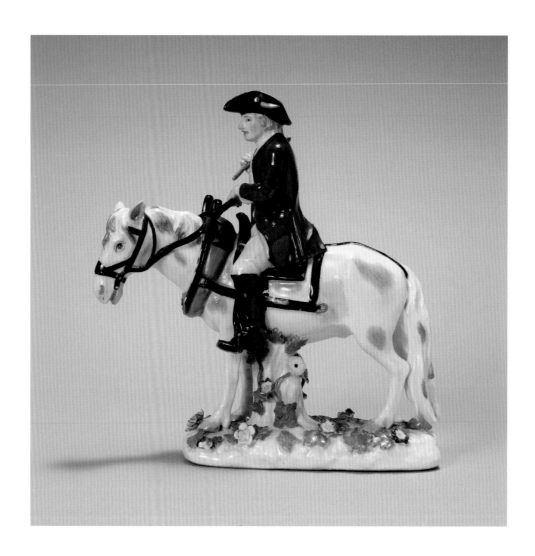

Fig. 53

Farmer on horseback
Meissen, c. 1745.
Hard-paste porcelain painted in enamel colours (and gilt to buttons).
Model by Johann Joachim Kaendler.
Height 21.3cm.

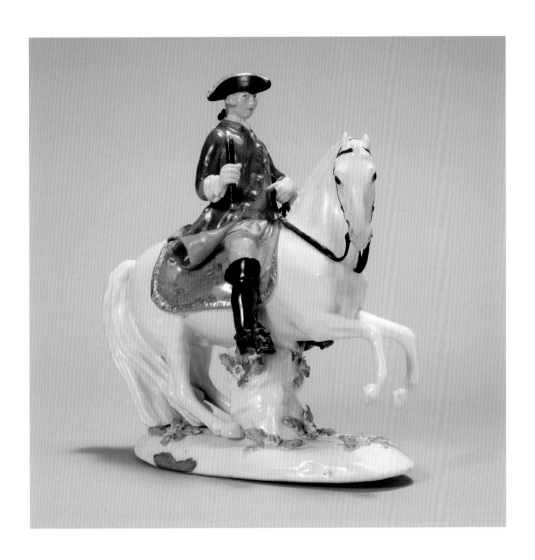

Fig. 54

Saxon officer on horseback wielding a field marshal's baton
Meissen, c. 1755.
Hard-paste porcelain painted in enamel colours and gilt.
Model by Peter Reinicke.
Height 18.2cm.

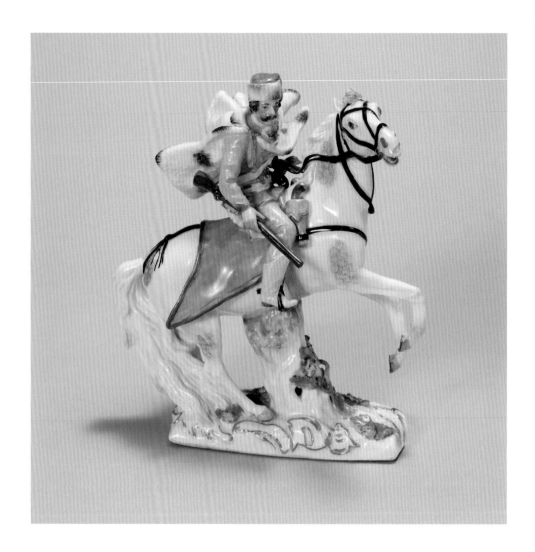

Fig. 55

Hussar on horseback
Meissen, c. 1750.
Hard-paste porcelain painted in enamel colours and gilt.
Model by Johann Joachim Kaendler and Peter Reinicke.
Height 17.2cm.

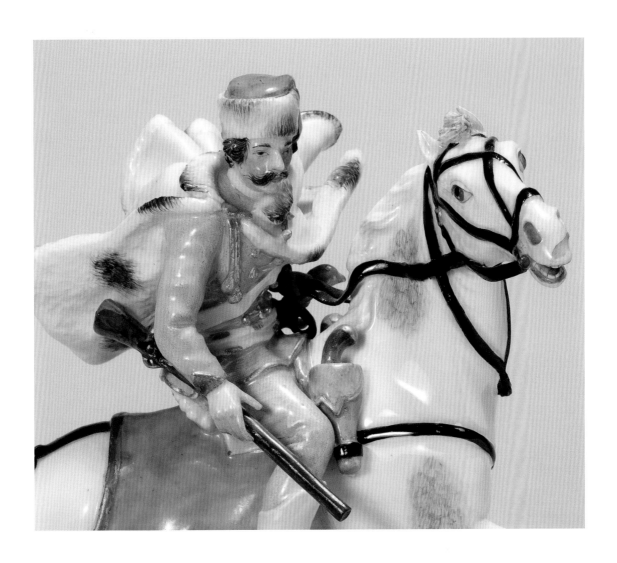

Fig. 55a

Detail of Fig. 55

Fig. 56

Drum major on horseback
Meissen, c. 1750.
Hard-paste porcelain painted in enamel colours and gilt.
Model by Johann Joachim Kaendler and Peter Reinicke.
Height 20.2cm.

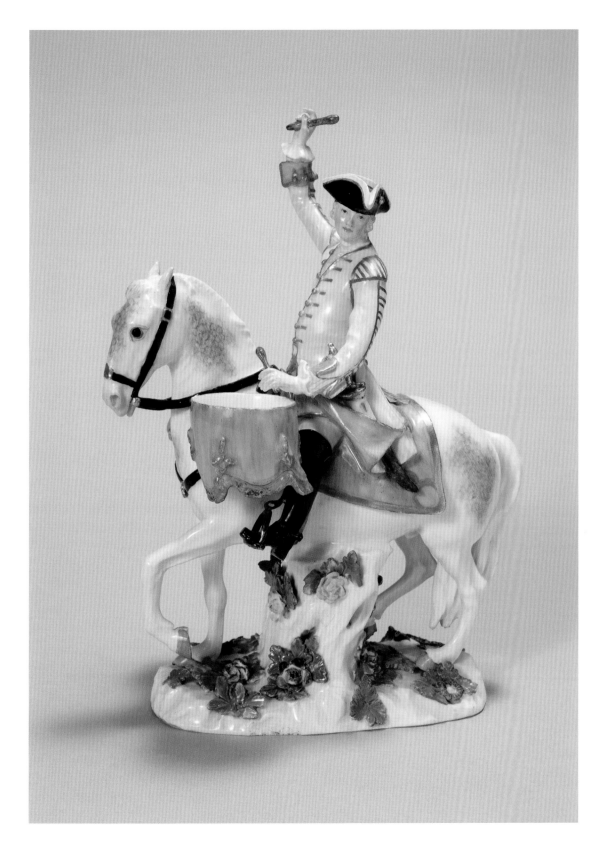

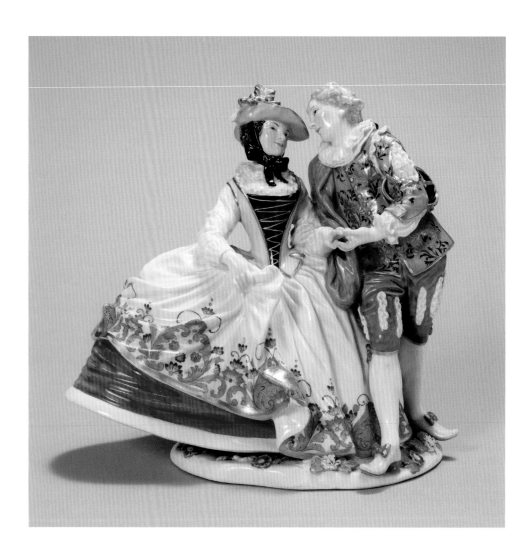

Fig. 57

Spanish Lovers: Beltrame and Columbine
Meissen, c. 1741.
Hard-paste porcelain painted in enamel colours and gilt.
Model by Johann Joachim Kaendler.
Height 18cm.

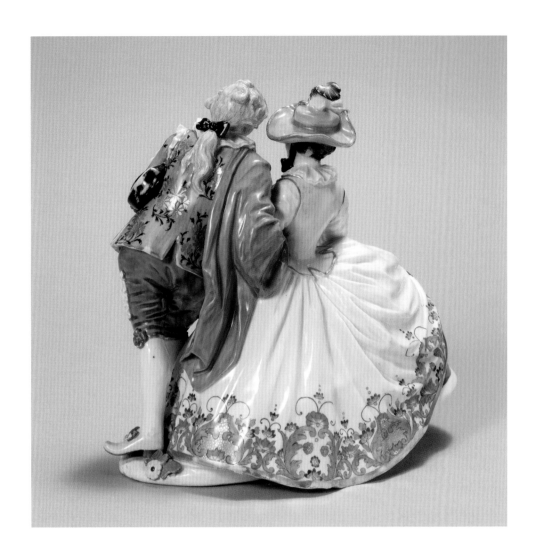

Fig. 57a

Same object as in Fig. 57, but from the back

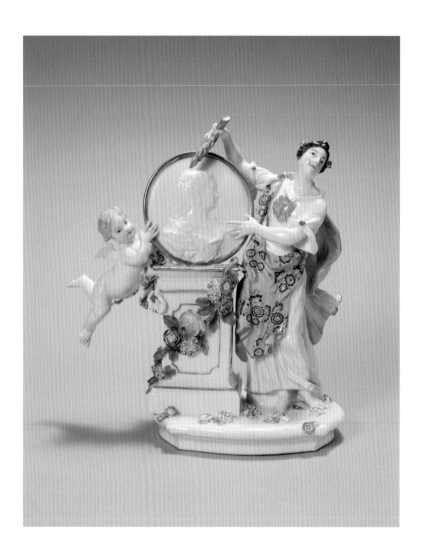

Fig. 58

Apotheosis of The Electress Maria Josepha of Saxony, Queen of Poland, Archduchess of Austria
Meissen, c. 1743.
Hard-paste porcelain painted in enamel colours and gilt.
Model by Johann Joachim Kaendler.
Height 23.8cm.

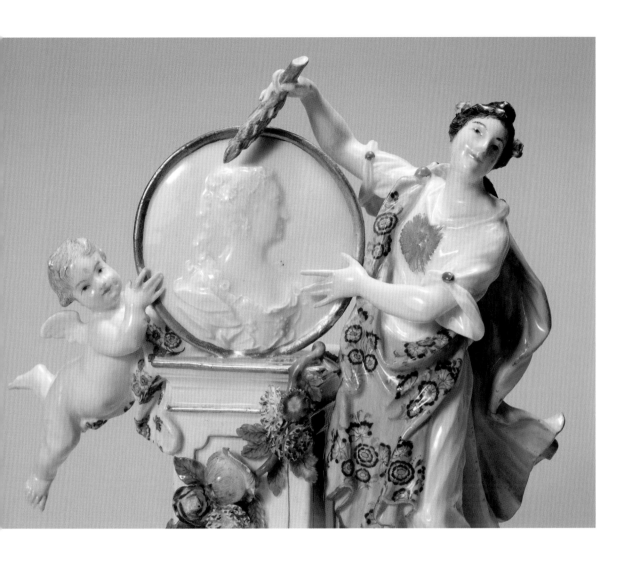

Fig. 58a

Detail from the figure in Fig. 58

 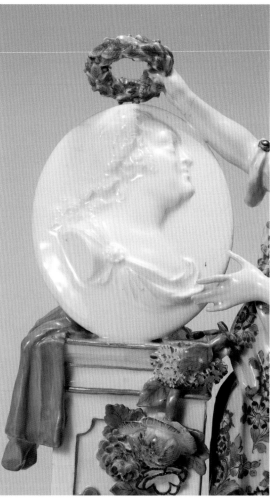

Fig. 59

Apotheosis of Augustus III, King of Poland, Elector of Saxony
Meissen, c. 1743.
Hard-paste porcelain painted in enamel colours and gilt.
Model by Johann Joachim Kaendler.
Height 23.5cm.

Fig. 59a

Detail from the figure in Fig. 59

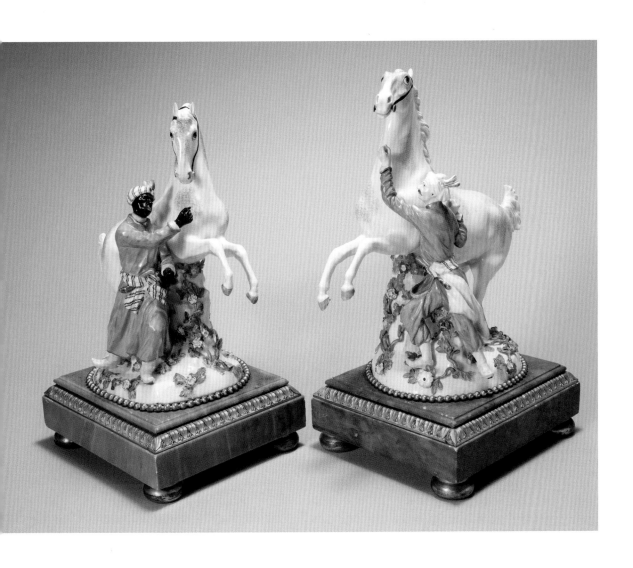

Fig. 60

The horse tamers: a pair of horses and grooms on stone and ormolu mounts
Meissen, c. 1750–55.
Hard-paste porcelain painted in enamel colours and gilt.
Model by Johann Joachim Kaendler.
Height 24.3cm (Moor) + 6.8cm for the base; height 26.3cm (Turk) + 7cm for the base.

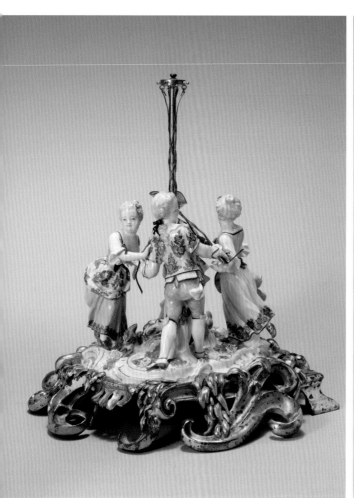 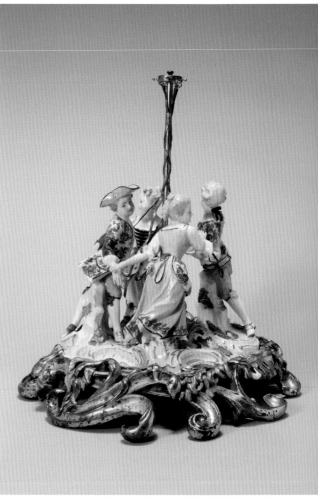

Fig. 61

Ormolu-mounted group of children dancing around a maypole
Meissen, c. 1760 (maypole probably nineteenth century).
Hard-paste porcelain painted in enamel colours and gilt.
Model by Johann Joachim Kaendler.
Height 29.8cm (to top of maypole, including the ormolu mount).

Fig. 61a

Another view of the object in Fig. 61

86

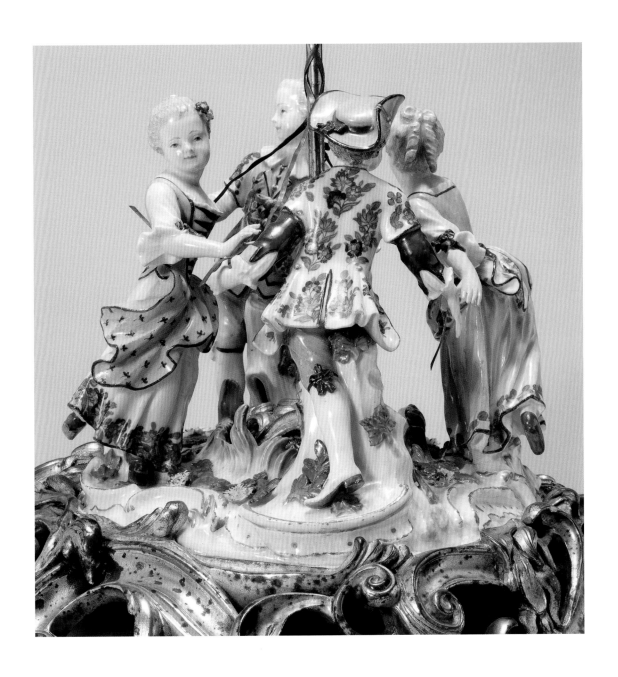

Fig. 61b

A close-up of the group in Fig. 61

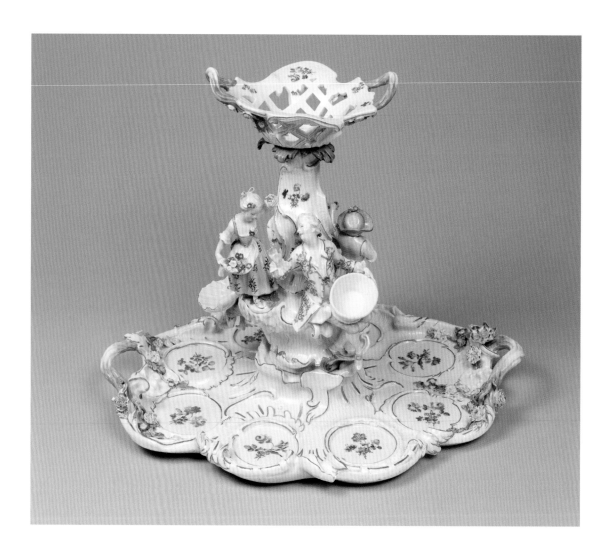

Fig. 62

The 'Mayerling' table centrepiece
Meissen, c. 1760.
When this table centrepiece was exhibited by the art dealer Philip Colleck in New York in 1949,
newspaper articles reported that it came from the Hunting Lodge at Mayerling, where the Hapsburg
Crown Prince Rudolf of Austria lived with his mistress Baroness Marie Vetsera – a passionate though
ultimately doomed affair immortalised in the ballet *Mayerling* [see Appendix II].
Hard-paste porcelain painted in enamel colours and gilt.
Models of the figures by Johann Joachim Kaendler.
Height 35.1cm; depth 34cm; width 45cm.

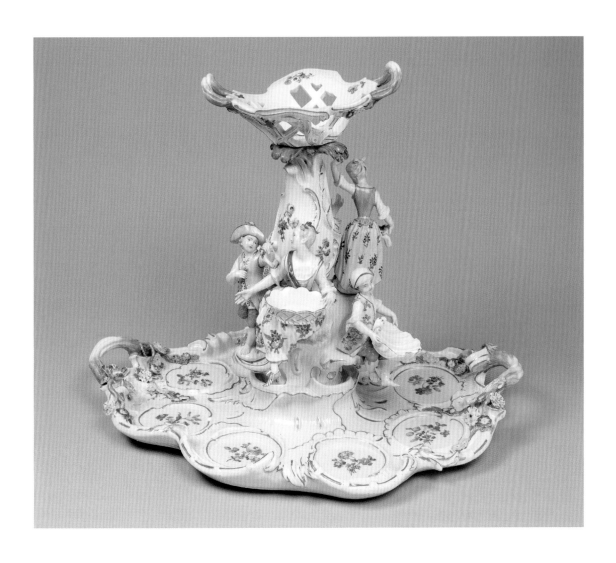

Fig. 62a

Another view of the centrepiece in Fig. 62

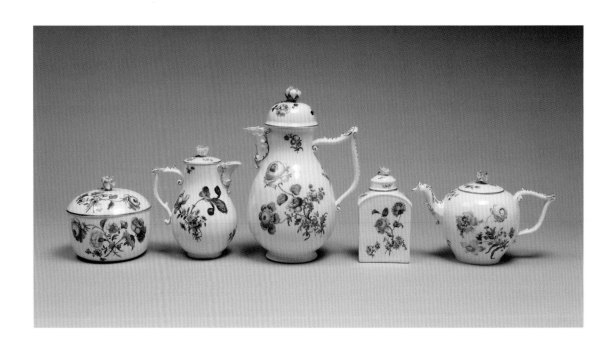

Fig. 63

(Left to Right) Sugar bowl, hot chocolate jug, coffeepot, tea caddy and teapot – each with lids.
See also Figs 64 and 65.

Meissen, c. 1750.

Hard-paste porcelain painted with 'Deutsche Blumen' in enamel colours and gilt. The naturalistic
flowers painted on the pieces of this tea service are recognisable and include, for example, irises. The
prevalence of tulips in the decoration is a reminder of that flower's enduringly deep-rooted popularity
across Europe since tulipomania in seventeenth-century Holland, when there was wild speculation and
excessive interest in tulip bulbs, which ended unhappily for some when the bubble burst.

Sugar bowl: height 11.3cm; diameter 11.6cm.

Hot chocolate jug: height 15.5cm.

Coffeepot: height 23.5cm (to top of knob).

Tea caddy: height 12.8cm (to top of knob).

Teapot: height 12.4cm (to top of knob).

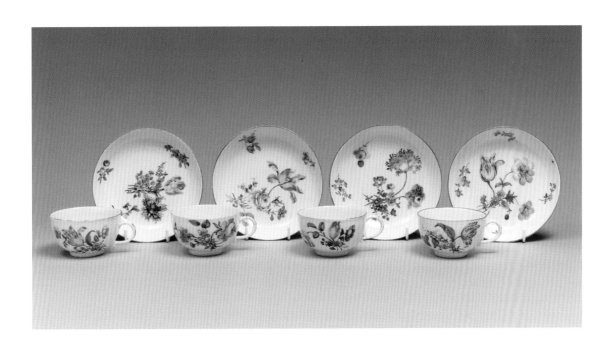

Fig. 64

A selection of four cups and saucers (from a collection of nine) from a floral tea service.
See also Figs 63 and 65.
Meissen, c. 1750.
Hard-paste porcelain painted with 'Deutsche Blumen' in enamel colours and gilt. There is also flower decoration inside the bottom of the cups.
Cups: height 4.7cm; diameter 8.1cm.
Saucers: height 2.8cm; diameter 13.5cm.

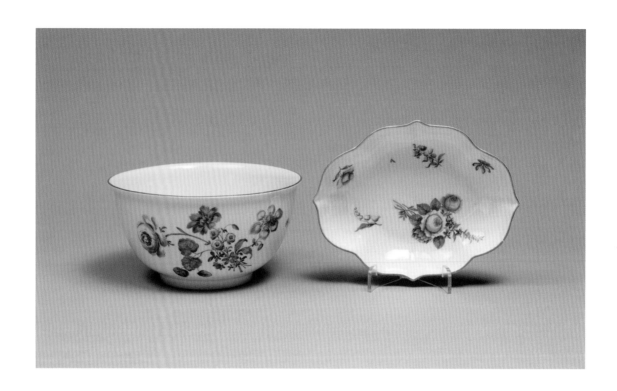

Fig. 65

Slop bowl and spoon tray from a floral tea service. See also Figs 63 and 64.
Meissen, c. 1750.
Hard-paste porcelain painted in enamel colours and gilt.
Slop bowl: height 9cm; diameter 17.5cm.
Spoon tray: height 3.3cm; width 14cm; length 17.8cm.

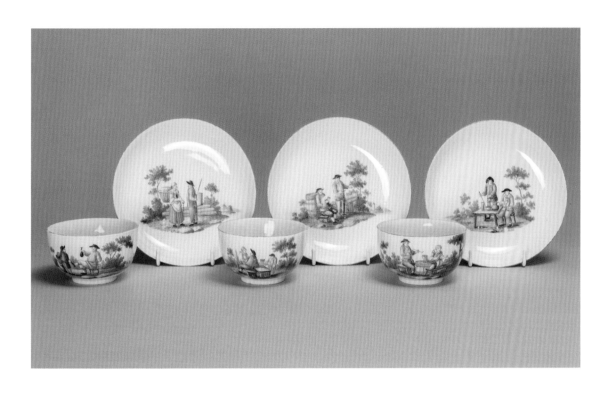

Fig. 66

Three cups and saucers from a tea service decorated with bucolic groups. See also Figs 67–69.
Meissen, c. 1730–40.
Hard-paste porcelain decorated with unidentified outside painting in enamel colours and gilt. There is flower decoration inside the bottom of the cups.
Cups: height 4.8cm; diameter 8cm.
Saucers: height 2.8cm; diameter 13.5cm.

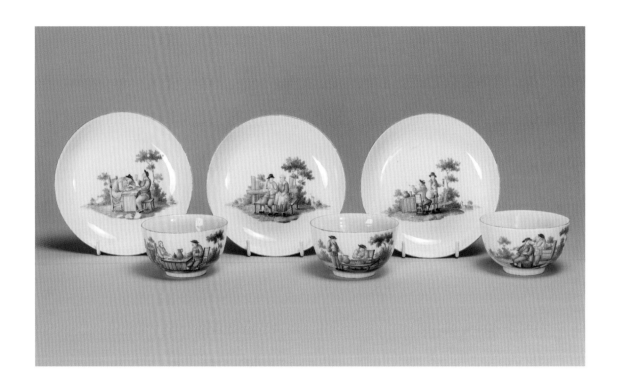

Fig. 67

Three further cups and saucers from a tea service decorated with bucolic groups.
See also Figs 66, 68 and 69.

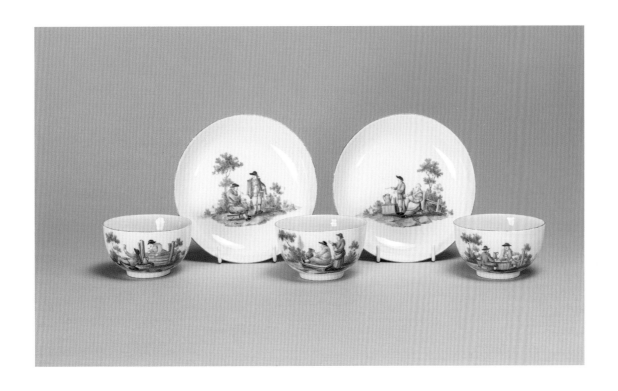

Fig. 68

Three further cups and two saucers from a tea service decorated with bucolic groups.
See also Figs 66, 67 and 69.

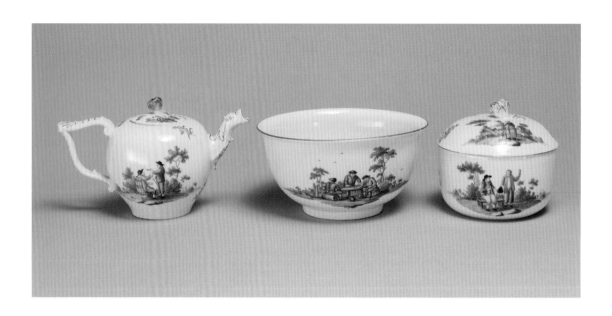

Fig. 69

Teapot with lid, a slop bowl and a covered sugar bowl from a tea service decorated with bucolic groups. See also Figs 66–68.

Teapot: height 11.7cm (to top of knob).

Slop bowl: height 8.9cm; diameter 17.2cm.

Sugar bowl: height 11.1cm (to top of knob); diameter 12cm.

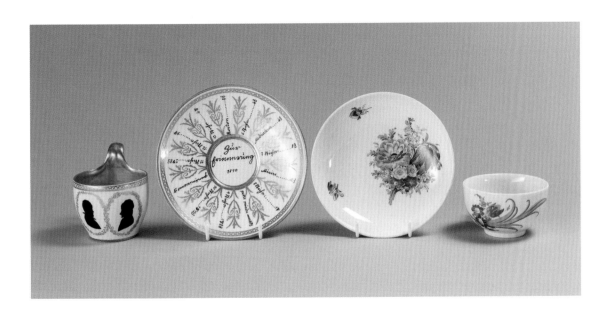

Fig. 70

(Left) Commemorative cup and saucer

Meissen, 1810.

Hard-paste porcelain painted in enamel colour and gilt. Outside decorated by Samuel Mohn of Dresden. The decoration honours and relates to a game of cards called 'Boston' played in 1810, most likely by the regrettably unidentified people represented in the silhouette portraits on the cup. The game 'Boston' is referred to in *War and Peace* by Leo Tolstoy.

Cup: height 8.2cm (to top of handle); diameter 7.3cm.

Saucer: height 2.5cm; diameter 14.7cm.

(Right) Marcolini cup and saucer

Meissen, c. 1774–1814 (crossed swords in underglaze blue with a star).

Hard-paste porcelain painted in enamel colours. There is also flower decoration inside the bottom of the cup.

Cup: height 4.7cm; diameter 8.3cm.

Saucer: height 2.8cm; diameter 13.9cm.

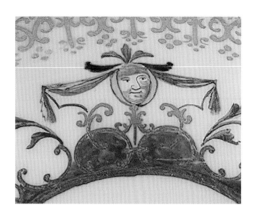

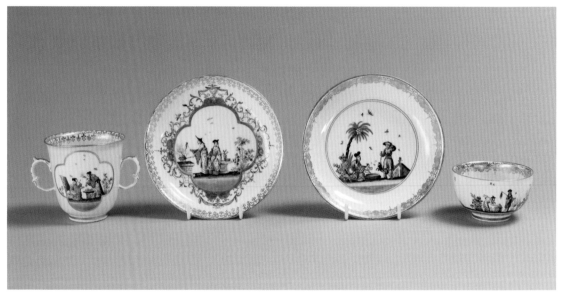

Fig. 71

(Left) A yellow-ground, two-handled chinoiserie decorated beaker and saucer
Meissen, c. 1740. Hard-paste porcelain painted in enamel colours and gilt. Decorated in the manner of Johann Gregorius Höroldt and his workshop. The medallion at the top of the saucer's cartouche is thought to be a self-portrait of Höroldt. See also Fig. 71a.
Beaker: height 7.7cm; diameter 8cm. Saucer: height 2.7cm; diameter 13.7cm.

(Right) Chinoiserie teabowl and saucer
Meissen, c. 1738. Hard-paste porcelain painted in enamel colours and gilt. Decorated in the manner of Johann Gregorius Höroldt and his workshop.
Teabowl: height 4.5cm; diameter 7.7cm. Saucer: height 2.5cm; diameter 13.8cm.

Fig. 71a (Top)
Detail of the saucer in Fig. 71, showing what is believed to be a self-portrait of the decorator, Johann Gregorius Höroldt

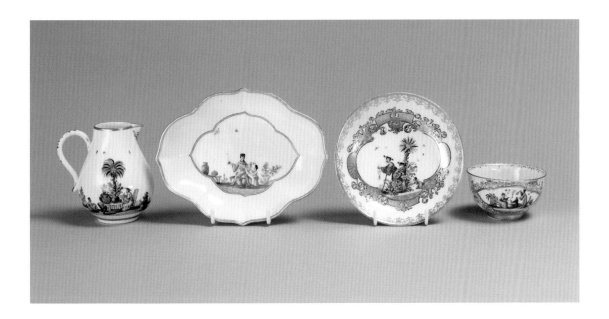

Fig. 72

(Left) Chinoiserie cream jug
Meissen, c. 1735. Hard-paste porcelain painted in enamel colours and gilt. Decorated with a continuous scene by Christian Friedrich Herold.
Height 9.7cm.

(Second from Left) Chinoiserie spoon tray
Meissen, c. 1730–40. Hard-paste porcelain painted in enamel colours and gilt. Decorated in the manner of Johann Gregorius Höroldt.
Height 3.8cm; width 13.8cm; length 17.7cm.

(Third and Fourth from Left) Chinoiserie saucer and teabowl
Meissen, c. 1735. Hard-paste porcelain painted in enamel colours and gilt. Decorated in the manner of Johann Gregorius Höroldt.
Saucer: height 2.9cm; diameter 13.1cm. Teabowl: height 4.6cm; diameter 8.2cm.

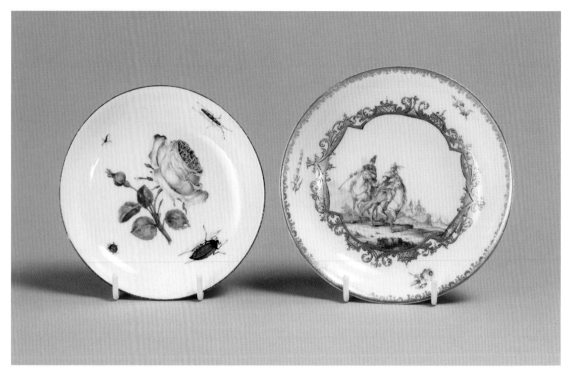

Fig. 73

(Left) 'Schattenmalerei' saucer
Meissen, c. 1740–46.
Hard-paste porcelain painted in enamel colours and gilt. The underside of the saucer has a yellow ground.
Height 2.5cm; diameter 12.4cm.

(Right) A circular dish
Meissen, c. 1750–55.
Hard-paste porcelain painted in enamel colour and gilt. Decorated in puce with a battle scene and
mounted hussars framed within an elaborate gilt cartouche.
Height 2.9cm; diameter 13.6cm.

Fig. 73a (Top)
**Detail of the 'Schattenmalerei', that is to say the painted decoration with shadows from the saucer
in Fig. 73**

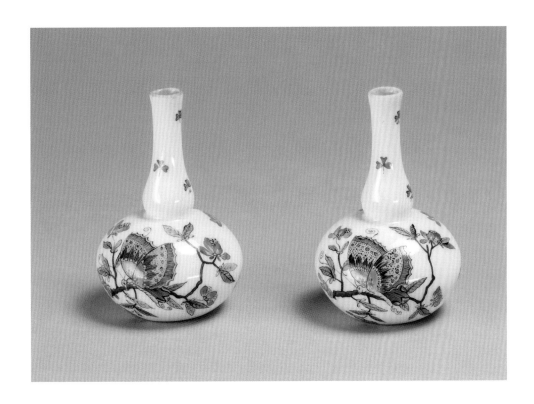

Fig. 74

A pair of miniature scent bottles
Meissen, c. 1740.
Hard-paste porcelain painted in enamel colours. Decorated in Kakiemon-style with butterflies and sprays bearing leaves and blossom.
Height 6.9cm.

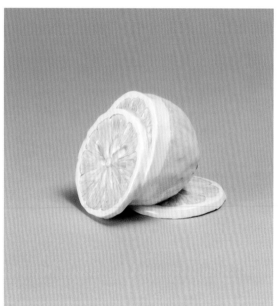 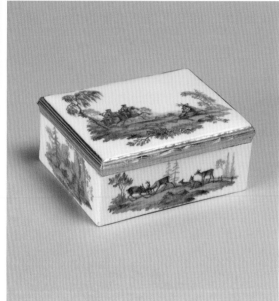

Fig. 75 (Left)

A realistically modelled lemon-shaped tureen knob
Meissen, c. 1743.
Hard-paste porcelain painted in enamel colours.
Height 5.3cm.

Fig. 76 (Right)

A giltmetal-mounted rectangular snuffbox
Meissen, c. 1750.
Hard-paste porcelain painted in enamel colours. Decorated on the outside with green monochrome
hunting scenes.
Height 3.9cm; length 8.5cm; width 6.9cm.

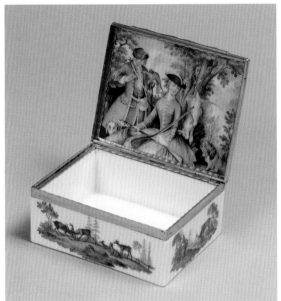 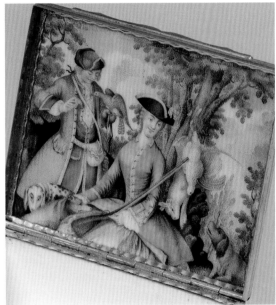

Fig. 76a

Inside of the open snuffbox shown in Fig. 76

On the inside of the lid there is a huntress and a falconer, together with hounds and dead game, painted in a stipple technique with small dots.

Fig. 76b

Detail of the snuffbox shown in Figs 76 and 76a

This close-up helps to see the painstaking stipple painting technique used to decorate the inside of the snuffbox.

Fig. 77

A Kakiemon sugar caster
Meissen, c. 1740–45.
Hard-paste porcelain painted in enamel colours. Decorated with a winged kylin, a crane and a spray of
'Indianische Blumen' (Eastern flowers). The screw-on cover has a flower-shaped finial and is in the form
of a pierced artichoke.
Height 16.9cm.

Fig. 77a
Another view of the sugar caster in Fig. 77

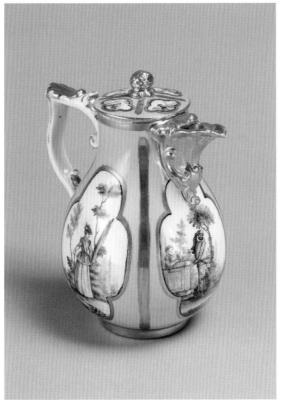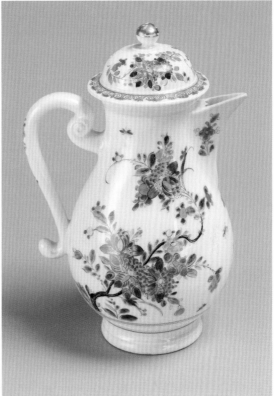

Fig. 78

Mocha pot with cover
Meissen, c. 1740.
Hard-paste porcelain painted in enamel colours and gilt. Decorated with turquoise ground and
Watteau-inspired Italian Comedy scenes painted in puce.
Height 14.3cm (to top of knob).

Fig. 79

A coffeepot with cover
Meissen, c. 1730.
Hard-paste porcelain painted in enamel colours and gilt. Decorated with Kakiemon-style 'Indianische
Blumen' (Eastern flowers) in the manner of Johann Ehrenfried Stadler.
Height 19.4cm.

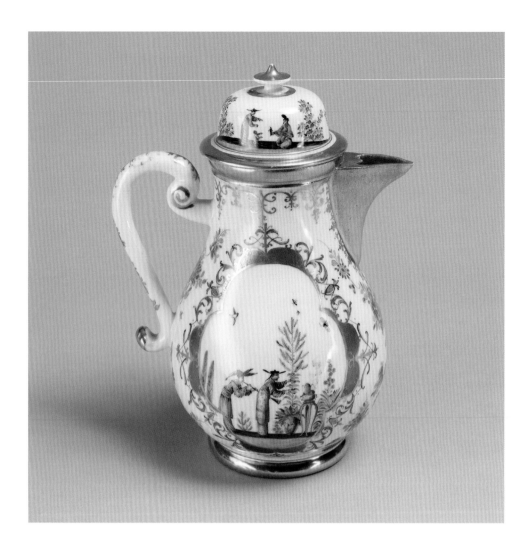

Fig. 80

A chinoiserie coffeepot with cover
Meissen, c. 1728.
Hard-paste porcelain painted in enamel colours and gilt. Decorated with chinoiserie scenes in the manner of Johann Gregorius Höroldt and at the spout side with a spray of 'Indianische Blumen' (Eastern flowers) in the manner of Johann Ehrenfried Stadler.
Height 19.8cm.

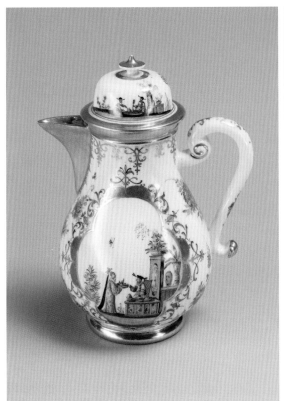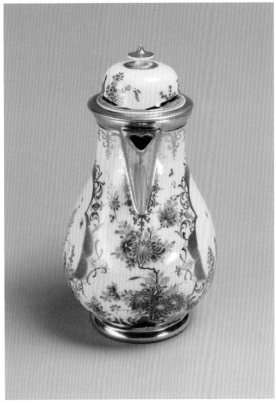

Fig. 80a
Another view of the coffeepot in Fig. 80

Fig. 80b
View of the coffeepot in Figs 80 and 80a from the spout side

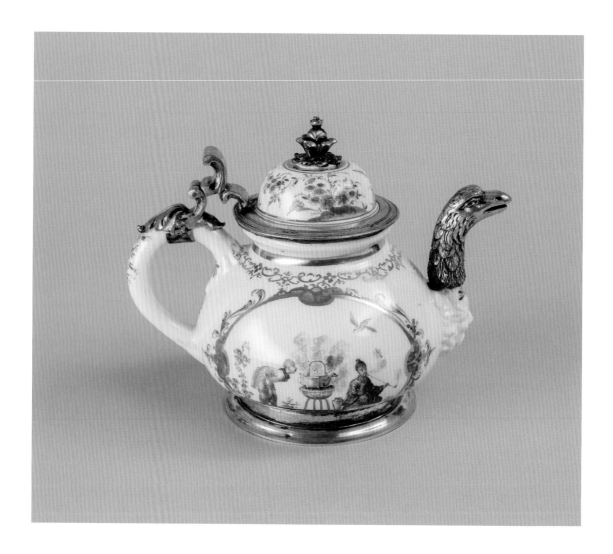

Fig. 81

A chinoiserie teapot with cover
Meissen, 1722 (on the base is the rare underglaze blue mark M.P.M. – Meissner Porzellan Manufaktur).
Hard-paste porcelain painted in enamel colours and gilt. Decorated with scenes by Johann Gregorius
Höroldt, the lid with sprays bearing blossom. The base, spout and lid have contemporary silver-gilt
Augsburg mounts, including a decorative knob.
Height 12cm.

Fig. 81a (Opposite top)
Another view of the teapot in Fig. 81

Fig. 81b (Opposite bottom left)
View from the spout side of the teapot in Figs 81 and 81a

Fig. 81c (Opposite bottom right)
View of the base of the teapot in Figs 81–81b

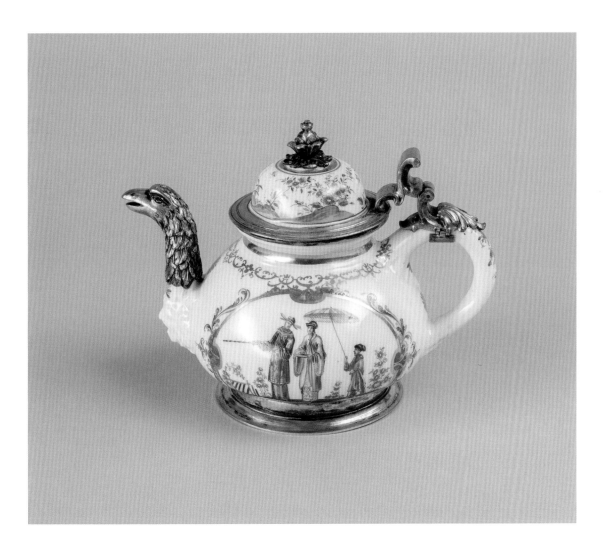

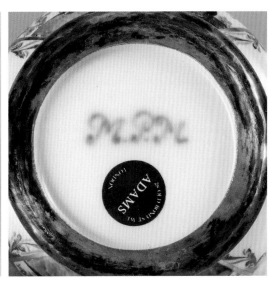

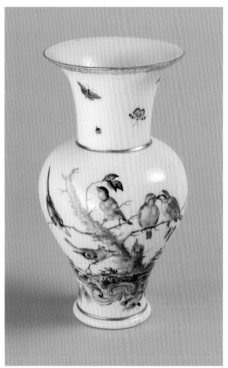
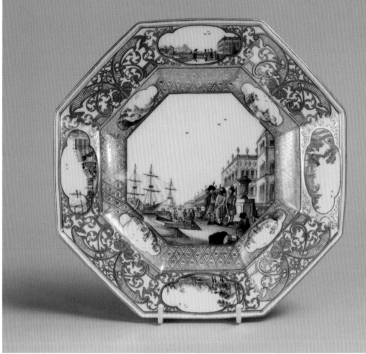

Fig. 82

A vase
Meissen, c. 1740–50.
Hard-paste porcelain painted in enamel colours and gilt. Decorated with representations of various birds perched on branches and other creatures, including some butterflies and a ladybird.
Height 15.9cm.

Fig. 83

An octagonal plate from the Christie-Miller service
Meissen, c. 1740–42.
Hard-paste porcelain painted in enamel colours and gilt. The borders feature eight quatrefoil panels with scenes, four of them in puce camaïeu, all set amongst elaborate gilding. In the centre the plate is decorated with a depiction of exotically clad people on a quayside with ships and grand buildings in the manner of Johann Gregorius Höroldt and his workshop.
Diameter 22.7cm (across the flat sides).

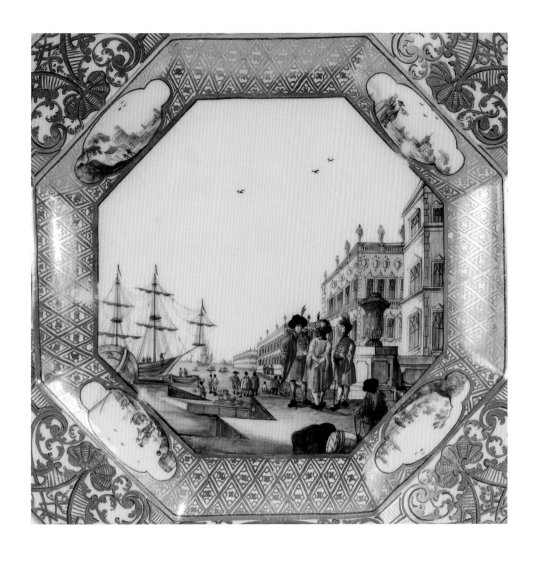

Fig. 83a
A close-up picture of the plate in Fig. 83

Fig. 84

A circular stand to accompany the écuelle in Fig. 85
Meissen, 1742.
Hard-paste porcelain painted in enamel colours and gilt. Decorated with scenes inspired by Watteau of lovers in a garden landscape attributed to Johann Christoph Horn.
Diameter 24cm.

112

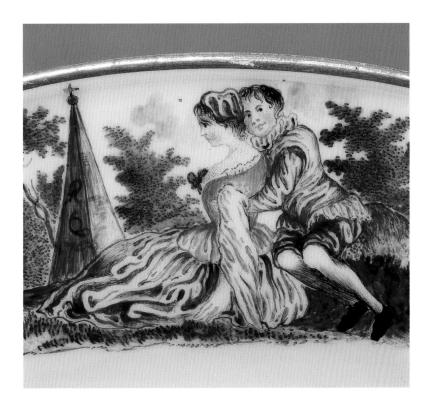

Fig. 84a

Detail of the stand in Fig. 84
The obelisk bears the interwoven monogram of the initials 'A' and 'R' for Augustus Rex, the date 1742, and there is also a coiled post horn, like those commonly used by postilions of the eighteenth century. A plate in the Haus zum Kirschgarten Museum in Basel bears a similar mark, which is to be understood there as a symbol of the royal mail service ['Zeichen der landesherrlichen Posthoheit']. The mark may, however, simply be an emblematic identifying mark playing on the surname of the decorator Johann Christoph Horn.

Fig. 85

A two-handled circular écuelle with cover
Meissen, 1742.
Hard-paste porcelain painted in enamel colours and gilt. This écuelle with cover go together with the stand in Fig. 84.
Height 13.2cm (to the top of the knob); diameter 16cm.

114

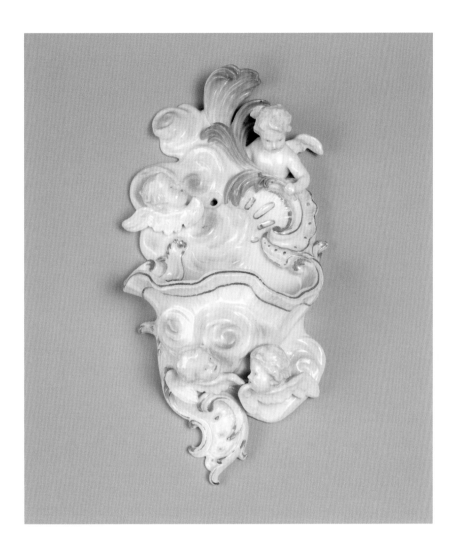

Fig. 86

A wall pocket, known as a stoup, decorated with cherubs
Meissen, c. 1770.
Hard-paste porcelain painted in enamel colours and gilt. Stoups are still found at the entrances of
homes of devout Catholics and contain holy water in which those entering may dip their fingers before
making a blessing.
Height 22cm.

Appendices

Appendix I
Inventory of Meissen objects in the collection:

- Table centrepiece x 1
- Vase x 1
- Sugar bowl with lid x 2
- Sugar caster x 1
- Tea caddy with lid x 1
- Cream jug x 1
- Spoon tray x 2
- Slop bowl x 2
- Chocolate jug with lid x 1
- Mocha pot with lid x 1
- Coffeepot with lid x 3
- Teapot with lid x 3
- Two-handled beaker x 1
- Teabowl x 2
- Cups x 20
- Saucers x 24
- Plate x 1
- Two-handled écuelle x 1
- Écuelle stand x 1
- Snuffbox x 1
- Stoup x 1
- Scent bottles x 2
- Tureen knob x 1
- Figures x 111

Appendix II

The newspaper clipping from a copy of *The New York Sun* in 1949 was part of an article announcing the opening of an antiques fair on 7 March 1949, headed: 'Fifth National Antiques Show Opens At Madison Square Garden Monday'. The article illustrated the 'Mayerling' table centrepiece [Fig. 62] and in the write-up it also states: 'Others will display objects of historical interest. Philip Colleck will show Meissen pieces from the hunting lodge where the Hapsburg Prince Rudolph lived with Marie Vetsera.'

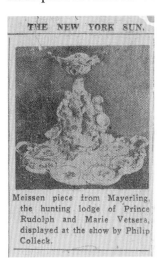

Meissen piece from Mayerling, the hunting lodge of Prince Rudolph and Marie Vetsera, displayed at the show by Philip Colleck.

Suggestions for Further Reading

Below is a short list of books and articles covering themes related to this catalogue and is intended as a guide rather than an exhaustive bibliography.

General books on ceramics

Cavanaugh, A. and M. Yonan (eds), *The Cultural Aesthetics of Eighteenth-Century Porcelain*, Farnham, 2010.

Coutts, H., *The Art of Ceramics: European Ceramic Design 1500–1830*, New Haven and London, 2001.

Gleeson, J., *The Arcanum: The Extraordinary True Story of the Invention of European Porcelain*, London, 1998.

Hillier, B., *Pottery and Porcelain 1700–1914: England, Europe and North America*, London, 1968.

Hofmann, F., *Das Porzellan der Europäischen Manufakturen im XVIII Jahrhundert*, Berlin, 1932.

Poole, J., *Plagiarism Personified? European Pottery and Porcelain Figures*, Cambridge, 1986.

Richards, S., *Eighteenth-century Ceramics: Products for a civilised society*, Manchester, 1999.

Schmidt, R., *Porcelain as an Art and a Mirror of Fashion*, London, 1932.

Books/articles on Meissen porcelain

Adams, L. and Y., *Meissen Portrait Figures*, London, 1987.

Adams, Y., *Meissen Figures, 1730–1775: the Kaendler Period*, Atglen, 2001.

Arnold, K.P., 'Cris de Paris und Cris de Londres: Seltene Meissner Figurenserien aus dem 18. Jahrhundert', *Porzellane und ausgewählte Kunstobjekte*, introduction to an auction catalogue held at Antiquitäten Metz GmbH, Heidelberg, Saturday 25 April 2009.

Chilton, M., *Harlequin Unmasked: Commedia Dell'Arte and Porcelain Sculpture*, New Haven and London, 2001.

Eberle, M., *Cris de Paris: Meissener Porzellanfiguren des 18. Jahrhunderts*, Leipzig, 2001.

Just, J., 'Londoner Ausrufer in Meißner Porzellan', *Dresdener Kunstblätter*, 16. Jahrgang, 1972, Heft VI, pp. 173-85.

Menzhausen, I., *In Porzellan Verzaubert: Die Figuren Johann Joachim Kändlers in Meißen aus der Sammlung Pauls-Eisenbeiss*, Basel, 1993.

Pauls-Eisenbeiss, E., *German Porcelain of the Eighteenth Century*, 2 vols, London, 1972.

Pietsch, U. and C. Banz (eds), *Triumph der blauen Schwerter: Meissener Porzellan für Adel und Bürgertum 1710–1815*, Leipzig, 2010.

Reinheckel, G., 'Die erste Folge der Pariser Ausrufer in Meissner Porzellan', *Keramos*, 50, 1970, pp. 115-21.

Reinheckel, G., 'Pariser Ausrufer: Die Zweite Folge in Meissner Porzellan und ihre Vorbilder', *Weltkunst*, Vol. 9, May 1992, pp. 1161-65.

Röntgen, R., *The Book of Meissen*, Pennsylvania, 1984.

Rückert, R., *Meissener Porzellan 1710–1810*, Catalogue of an exhibition in the Bavarian National Museum in Munich, Munich, 1966.

Books/articles on chinoiserie, turquerie and russerie

Impey, O., *Chinoiserie: the Impact of Oriental Styles in Western Art and Decoration*, London, 1977.

Impey, O., *Porcelain for Palaces: The Fashion for Japan in Europe, 1650–1750*, exh. cat., British Museum, London, 1990.

Reau, L., 'L'Exotisme russe dans l'œuvre de J. B. Le Prince', *Gazette des Beaux-Arts*, 4, iii, 1921, pp. 147-65.

Rorschach, K., *Drawings by Jean-Baptiste Le Prince for the 'Voyage en Sibérie'*, Rosenbach Museum, Philadelphia, 1986.

Williams, H., *Turquerie: An Eighteenth-Century European Fantasy*, London, 2014.

Books on street hawkers/cries

Beall, K., *Kaufrufe und Staßenhändler: Cries and Itinerant Trades*, Hamburg, 1975.

Calaresu, M. and D. van den Heuvel (eds), *Food Hawkers: Selling in the streets from antiquity to the present*, Abingdon, 2018.

Shesgreen, S., *The Criers and Hawkers of London: Engravings and Drawings by Marcellus Laroon*, Aldershot, 1990.

Shesgreen, S., *Images of the Outcast: the Urban Poor in the Cries of London*, Manchester, 2002.

Books on the Enlightenment

Gay, P., *The Enlightenment: An Interpretation*, 2 vols, London, 1967/1970 (reprinted 1996).

Hampson, N., *The Enlightenment: An Evaluation of its Assumptions, Attitudes and Values*, London, 1990 (first pub. 1968).

Outram, D., *The Enlightenment*, Cambridge, 1999 (first pub. 1995).

Outram, D., *Panorama of the Enlightenment*, London, 2006.

List of Illustrations

Fig. 17: (Left) Hawker with liquorice water or tisane from the Cries of Paris; (Right) Hawker with pastries from the Cries of Paris

Fig. 18: (Left) Hawker with lemonade from the Cries of Paris; (Right) Hawker with pastries and lemonade from the Cries of Paris

Fig. 19: (Left) Hawker with oysters from the Cries of Paris; (Right) Hawker with fish from the Cries of Paris

Fig. 20: (Left) Hawker with vegetables or herbs from the Cries of Paris; (Right) Street food hawker beside a stove from the Cries of Paris

Fig. 21: (Left) Hawker plucking a bird from the Cries of Paris; (Right) Hawker with poultry and basket of eggs from the Cries of Paris

Fig. 22: (Left) Hawker with tray of goods and a jug from the Cries of Russia; (Second from Left) Hawker carrying a tub of fish on his head from the Cries of Russia; (Third from Left) Hawker of pretzels from the Cries of Russia; (Right) Hawker with basket of goods from the Cries of Russia

Fig. 23: (Left) Hawker with jug of water or lemonade from the Cries of Russia; (Right) Water carrier or milkmaid from the Cries of Russia

Fig. 24: Troika, or sleigh [horse(s) missing], with driver and two passengers from the Cries of Russia

Fig. 25: (Left) Woman vegetable hawker from the small-scale Farmer Series; (Second from Left) Peasant leaning on a staff from the small-scale Farmer Series; (Third from Left) Vintager gathering grapes from the small-scale Farmer Series; (Right) Woman vintager gathering grapes from the small-scale Farmer Series

Fig. 26: (Left) Sower from the small-scale Farmer Series; (Second from Left) Peasant reaping wheat with a scythe from the small-scale Farmer Series; (Third from Left) Peasant grafting or pruning from the small-scale Farmer Series; (Right) Peasant with rake from the small-scale Farmer Series

Fig. 27: (Left) Peasant digging with a spade from the small-scale Farmer Series; (Right) Peasant tilling or hoeing from the small-scale Farmer Series

About the Author and Photographer

Philip Kelleway is an art historian. Since completing his doctorate on ceramics, Kelleway has written peer-reviewed journal articles and books on topics including eighteenth-century porcelain, illustration and landscape painting. He is an authority on the work of the Zinkeisen sisters and has published his findings on them, including co-authoring *The Art of Doris & Anna Zinkeisen* (2021), also published by Unicorn.

Tristan Sam Weller is a cinematographer, photographer and artist. Past commissions include directing music videos, documentary work for international disaster relief and live camera production for the Latitude and the Green Man Festivals. Weller is also a practising acupuncturist, having studied Chinese and Japanese acupuncture. His father was the sculptor Anthony Weller, his mother is the painter Julia Heseltine, whilst his maternal grandmother was the renowned artist Anna Zinkeisen.

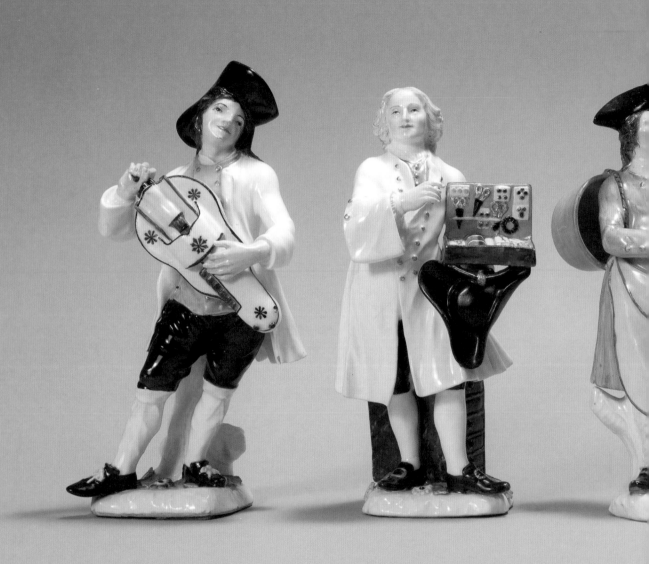